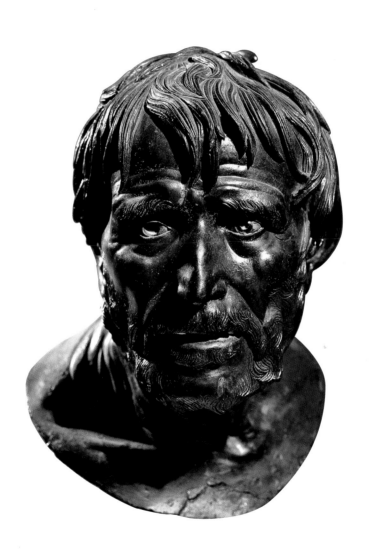

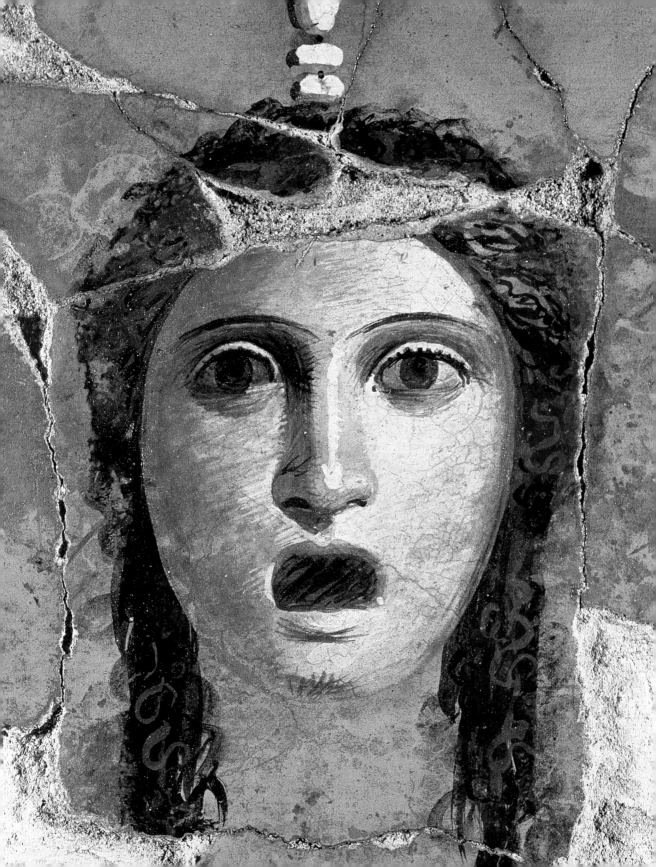

Roman Art

MICHAEL SIEBLER
NORBERT WOLF (ED.)

TASCHEN

HONG KONG KÖLN LONDON LOS ANGELES MADRID PARIS TOKYO

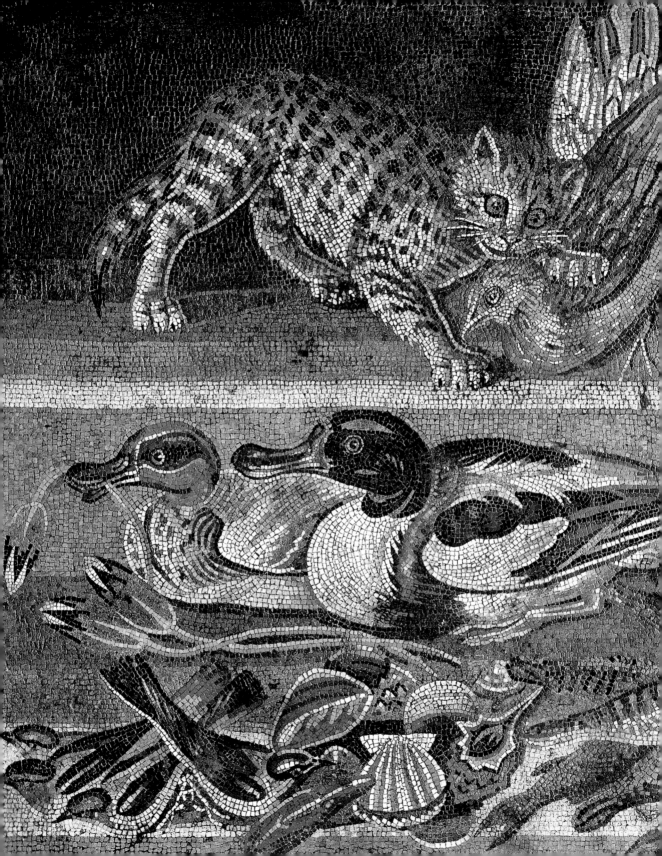

contents

visual arts in the centre of the empire

It could be said that Mars, the god of war, stood at the cradle of Rome, since according to legend he was responsible for what was in that cradle: the twins Romulus and Remus. Mars was officially considered to be their father. As is the case so often in heroic legends, the two newborn infants were in the way of a usurper. Romulus and Remus represented a threat to their great-uncle Amulius so he abandoned them on the banks of the River Tiber. A she-wolf found the twins and adopted them as her young, since she had lost her own. They were later discovered by the shepherd Faustulus who together with his wife then raised the god's children. Either chance or divine providence brought them to the royal court in Alba Longa, where they recognized their grandfather Numitor, quickly slew their great-uncle Amulius, and put Numitor back on the throne. As befits heroes, they then planned to found a city. Romulus wanted to found it on a hill called the Palatine, while Remus favoured the neighbouring Aventine Hill. When Romulus set to work on 21st April 753 BCE, building a wall around his designated city area, Remus foolishly and mischievously jumped over it and paid for this inanity with his life. Romulus named the city after himself: Roma – Rome.

The story fits a true heroic legend and even names an exact date for the city's foundation. However: it is just a nice legend that only received its canonical shape very much later. Rome's beginnings, as is so often the case with old settlements, lie in the obscurity of pre-history. Nor can it be said that anything indicated that this location on the banks of the Tiber some 30 kilometres from the coast would be the birthplace of a future world power. True, there was a ford for a trade route across the Tiber just behind an island where an emporium and marketplace developed – but comparable conditions existed in other places, too.

Signs of human occupation begin in the 3rd and 2nd millennia BCE. Continuous settlement had existed there since the tenth century BCE, first on the Palatine, one of the seven hills on and between which Rome would extend in the future. Three free-standing hills, known as *montes,* and four hill ridges, known as *colles,* can be made out. The hills were the Palatine, with a sizable settlement area, the Capitoline, a steep, narrow hill with important temples, such as that of Jupiter Capitolinus, and the Aventine, the hill of the lower classes, the *plebs.* The four hill ridges – the Quirinal, the Viminal, the Esquiline, and the Caelian – were connected to the hinterland. The valleys contained the Forum Boarium (the commercial market with the Tiber ford and the oldest bridge), the Forum Romanum (the political and economic centre) and the Campus Martius, the army's assembly place and training ground.

21st April 753 BCE — **Legendary founding of Rome** from 578 BCE — **Construction of the Servian Wall around the city**
510/509 BCE — **Overthrow of the last Etruscan king Tarquinius Superbus; beginning of the Roman Republic**

"Rome experienced its first childhood under Romulus, its founder and nurturer. It passed its boyhood under the other kings. When it felt grown up it no longer put up with the servitude; it preferred to listen to laws instead of kings. This adolescence ended with the Punic war. Rome became stronger and entered the early prime of his life."

Seneca the Elder, c. 55 BCE – c. 37 CE

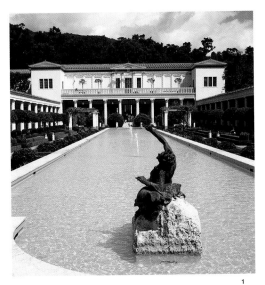

1. RECONSTRUCTION OF THE VILLA DEI PAPIRI IN POMPEII
for the J. Paul Getty Museum in Malibu, California

1

In the sign of the she-wolf

In visual art the legend of Romulus and Remus with the she-wolf can be traced back to at least the third century BCE. It may however have been known about earlier in the streets and households of Rome – and must have been taken at face value by many. A silver coin dating from around 269 BCE depicts the *Lupa Romana* thoughtfully caring for the twins (ill. p. 9). An up-and-coming city like Rome that was getting ready to one day rule a world empire did well to present a solid founding myth and thus a firm place in history to the powers of the time – to friends, but particularly also to foes. Even though Mars, the god of war, fell into the background somewhat, overshadowed by the main and city god Jupiter Optimus Maximus, he did receive a revival with the foundation of the Roman empire under Augustus, when he had a temple built in the god's honour in his Forum Augustum.

Rome's rise was unstoppable. The small community on the banks of the Tiber became a powerful force to be reckoned with. After Rome had conquered central Italy she reached for world domination. One after the other Rome eliminated her enemies. Occasionally the city was itself under severe threat. Carthage, the naval power in the western Mediterranean, was defeated in the three Punic wars begin-

ning in 264 BCE, and was finally destroyed in 146 BCE. In 211 BCE Syracuse fell, followed by Tarentum (Taranto) two years later. The eastern Mediterranean with the great Hellenistic powers, such as Syria under Antiochus III, and the Greek city states suffered the same fate. Thus Philip V of Macedon was defeated by the Roman Titus Quinctius Flaminius at Cynoscephalae in 197 BCE. Antiochus III was defeated a few years later at the Battle of Magnesia and in 146 BCE – the same year Carthage was destroyed – the Romans took Corinth and set up the province of Achaea. Finally, Attalus III bequeathed his kingdom of Pergamon to Rome in 133 BCE. Pergamon was considered a place where Greek art and culture were writ large. Now the Roman senators were in charge of the east.

In those decades, and subsequently, the victors of these and other wars removed ever larger quantities of artworks from the conquered peoples and presented them to their amazed populace during their triumphal processions. It can hardly be judged what treasures of gold and silver, or royal tableware and valuable jewellery, famous paintings, marble and bronze sculptures and much more were carried through the streets of Rome and subsequently used for the adornment of temples, plazas, and private households. A silver-gilt bowl can give some idea of the kinds of valuables brought to Italy as spoils of

474 BCE — Roman victory over the Etruscans

451/450 BCE — "The Twelve Tables", the first codification of the law

399 BCE — Death of Socrates in Athens

387 BCE — Rome destroyed by Celts crossing the Alps

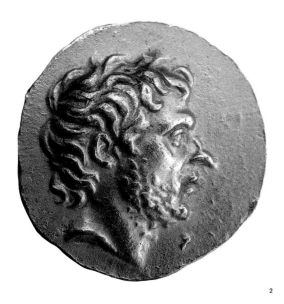

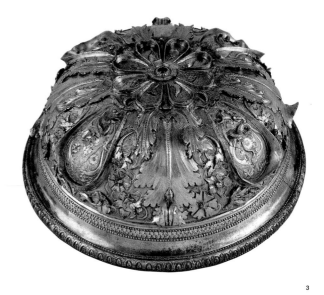

2

3

war or acquired as luxury objects (ill. p. 8). The bottom shows a flower with a garnet in its centre, entwined by golden and silver acanthus leaves as well as longer leaves. The technical execution suggests it was made in either Syria or Pergamon.

Images of power

The personal vanity of the generals and powerful citizens went hand in hand with Rome's military successes. They did not just have their deeds celebrated, they also claimed to play an outstanding role for the republic. A Greek gold coin can maybe give a taster of these men's self-confidence. It was struck shortly after the battle of Cynoscephalae in Macedonia (ill. p. 8). It clearly portrays the victor Titus Quinctius Flamininus. He is shown with a beard and without a helmet. The gold stater is Greek, but it was spent by a Roman who had had his portrait immortalized on it − during his lifetime. Basically this was outrageous for a Roman. Caesar was the first in 44 BCE to be given the right by the senate to have his image struck on coins during his lifetime.

Honorary statues for deserving politicians and victorious generals erected in the forum or other public places by decree of the senate and the people were on the other hand considered good manners amongst the greats of the republic. The person being honoured could be depicted as a politician or orator in a Roman toga or as a military commander wearing a breast plate, and, in rare cases riding a horse; the most impressive example of this must be the equestrian statue of Marcus Aurelius located on the Capitoline Hill. It was extensively restored a few years ago. Such likenesses, which listed on the statue's pedestal the public offices the subject had held and contained encomiums about his deeds, could be a serious weapon in a public confrontation with the political opponent, in the fight for the people's favour. For that reason it is not surprising that the victors of the civil wars of the second and first centuries BCE − even though they may have only been in power for a short period of time − frequently had the statues of those they had defeated overthrown.

Two of the most powerful men of the time were Gnaeus Pompeius Magnus (106–48 BCE) and Gaius Julius Caesar (100–44 BCE). Both men were thoroughbred politicians and magnificent military commanders. Initially, they believed they could secure their own position of power best by forming an alliance with each other. Thus they formed the first triumvirate together with the richest man in Rome, Marcus Licinius Crassus, in 59 BCE. It was such a formidable

343/42 — Aristotle becomes tutor to Alexander the Great　　　　　　　**326–304 BCE — Second (Great) Samnite War**
330 BCE — The seaport of Ostia is secured by a castrum　　　**312/311 BCE — Construction of the Via Appia**

**2. MACEDONIAN STATER WITH
THE PORTRAIT HEAD OF TITUS
QUINCTIUS FLAMININUS**
c. 195 BCE, gold, diameter 18 mm, weight 8.44 g
London, The British Museum

3. BOWL
Hellenistic, silver-gilt, height 7.3 cm,
diameter 13.4 cm
Naples, Museo Archeologico Nazionale

**4. ROMULUS AND REMUS BEING
SUCKLED BY THE ROMAN SHE-WOLF**
c. 269 BCE, didrachmon, silver
Rome, Museo Nazionale Romano,
Palazzo Massimo

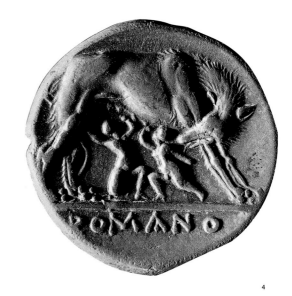

4

alliance that no other politician stood a chance against it. Pompeius (Pompey) even entered a family relationship with Caesar when he married the latter's daughter Julia that same year. Marriages were a popular means in ancient times to strengthen alliances or ambitions for power. Julia however died in childbirth in 54 BCE and the relationship between the two rivals soured noticeably. The two men who had once been partners and relatives became deadly enemies. In the end it was Pompey who lost the battle for power.

The portrait of Pompey (ill. p. 17) takes as its model the iconography of the Hellenistic rulers in the east. As a famous military commander, Pompey consciously liked to compare himself to his great role-model Alexander the Great (356–323 BCE). Thus he not only called himself *magnus,* "the great", but also styled the hair on his forehead into a so-called anastole – a curl that stood up and was intended to recall a lion's mane. It was a reference every halfway educated person would have understood very well.

The podgy face with the small squinting eyes and the overall sedate and worthy physiognomy do not seem to fit in with this claim. However, even those traits were seemingly desired and part of the political fashion of the time. Pompey wanted to use this likeness to replace the image of his previous appearances in public and the senate,

appearances marked by pomp and attitudes of power. Now, in 55 BCE, he had to highlight his Roman virtues – regardless of Alexander the Great – to dispel the mistrust formed against him. These included clemency, restraint and philanthropy; modesty and closeness to the populace in the forum were also important. Overall, it was a propagandistic balancing act – but one that was to pay off. Even after his death in 48 BCE it ensured that Romans thought positively of him in the end – even Caesar had the demolished statues of Pompey re-erected.

Caesar's portrait also reflects the self-image of the good statesman, as was expected by his contemporaries. Pompey's likenesses display a certain affability and closeness to the populace, whereas Caesar's, the dictator and overthrower of the republican state order, are dominated by level-headedness, rationality, and the ability to cope with deprivation. In contrast to Alexander the Great, Caesar saw his military abilities in his restraint, asceticism, and impassive superiority. The so-called Chiaramonti effigy is distinguished by energetic, sharp-edged facial features, tense, wrinkled facial muscles, and an intense stare (ill. p. 16). It was with these characteristics that Caesar finally set himself apart from the self-representations of others who had emerged victorious in the Civil War. Unlike Caesar's, their portraits blatantly demonstrate their pretensions to power.

280–275 BCE — Pyrrhic Wars **269 BCE — Start of Roman silver coinage**
264–241 BCE — First Punic War between Rome and Carthage

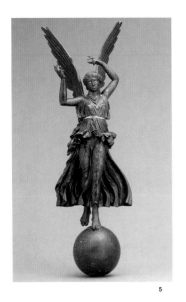

5

"since everything that is born also has to die, the citizens will fight each other as soon as Rome's death seems close. only then will they, tired and exhausted, fall victim to a king or a foreign nation. if this does not occur, neither the entire world nor all peoples put together have the power to break or harm this Roman empire."

Sallust, in a letter to Caesar

This small group of patricians, this oligarchy of politically influential men who had come to great wealth through aristocratic parentage or had helped their personal ambitions through skill, military experience, and ruthlessness, invested their fortune in large land holdings with extensive villas. In addition this group's representatives bound a large number of clients to them through favours and assistance. They had already become well acquainted with their role-models for their luxurious lifestyles at the ruling courts of the Hellenistic east. In the beginning they had to be considerate of the sensitivities of their fellow countrymen when they had themselves represented in public. However, in their own homes, behind closed doors as it were, they could live out their passion to the full, without exposing themselves to the charge of *luxuria* – of living a life wallowing in luxury – and thus of un-Roman behaviour.

greece: the artistic role model

The villas became reservoirs of Greek art and Greek imagery, as befitted the new ruling class (ill. p. 7). By conquering the Greek world they had basically become heirs to the culture that had seen its own classical past as a consummate whole, as both exemplary and authoritative. Whoever thought anything of himself decorated his gardens, his dining and reception rooms with copies of famous masterpieces or commissioned agents to acquire art from workshops in Athens or somewhere else, art that while new, was worked in archaic or classical fashion; these items might be statues, richly ornamented candelabra, or elaborately decorated containers. Originals from the 6th or 5th centuries BCE seem to have been rare. Generally speaking, they were exhibited in places accessible to the public, such as plazas, temples, or baths.

The walls of the villas were painted with many different motifs, and of course the models for them also came from Greece. Thus the paintings could depict rows of columns in front of the wall and projecting entablatures, thus optically enlarging the rooms and providing a backdrop of views of gardens, landscapes, temples, or mythical scenes. However, individual pictures or picture series could also decorate the walls. One of the most impressive examples of this kind is surely the picture gallery in a salon of Villa Boscoreale. Here, life-sized figures act in front of walls as on a rostrum: deities such as Venus and Dionysus, humans such as Ariadne, the daughter of King Minos, or a philosopher, the graces, as well as Eros and Psyche; finally, the left

from 250 BCE — Start of large-scale art imports from conquered cities
218–201 BCE — Second Punic War; after the Roman victory Africa is reorganized

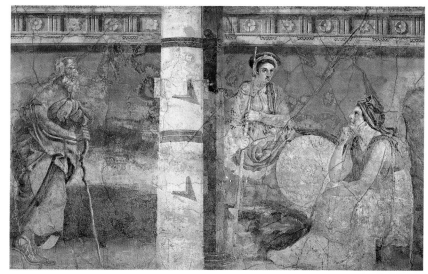

6

5. STATUETTE OF THE VICTORY GODDESS VICTORIA ON A BALL (SO-CALLED VICTORIA FOSSOMBRONE)
Copy after a Greek/southern Italian (from Taranto) original, c. 150 CE, bronze, height 67 cm
Kassel, Staatliche Museen Kassel

6. PERSONIFICATIONS OF THE COUNTRIES OF MACEDONIA AND PERSIA FROM THE VILLA BOSCOREALE
c. 50–40 BCE, wall painting
Naples, Museo Archeologico Nazionale

wall shows personifications of the countries Macedonia and Persia (ill. p. 11).

Macedonia is wearing the "Kausia", the typical royal cap, and is holding a lance; a round shield with the eight-rayed star of the royal Macedonian house is covering her legs. She is thoughtfully looking at Persia who is sitting at her feet and is wearing a turban-like headdress. *Persia,* who has adopted a pose of melancholy, resting her chin in her hand, seems already to be anticipating her future fate, namely her conquest by Alexander the Great. The models for these and similar motifs came from Macedonia and from the royal courts of the Diadochi, who considered themselves the successors of Alexander and accordingly chose to mythically exaggerate his deeds. This megalography or large-figure painting in Boscoreale is dated to around the mid-1st century BCE, when Pompey reordered the East and gave himself the sobriquet "the Great" in the style of Alexander, and Alexander was generally considered the role-model for every person of power.

It was also popular to have one's own four splendid walls decorated with copies of famous paintings by Greek masters. It is often possible to recognize more or less accurate reproductions of older models in the pictures found in the villas of Pompeii and elsewhere, depicting scenes from Greek mythology (but not exclusively). Unfortu-nately, we do not know which originals these were. One of the pictures is *Perseus Frees Andromeda* from the Casa dei Dioscuri in Pompeii (ill. p. 16). A further surviving execution of this motif shows that there must have been a famous model – but which one? Of course it is tempting to ascribe it to a master such as Nicias from whom we have one such surviving subject, but in the end the search for the creator should be abandoned, just as no scholar is still seriously looking for the long-lost original from the 4th century BCE.

Anyone who decorated his house with such and other paintings, erected faithful copies or reproductions of masterpieces from Athens and Corinth in his garden, or decided on contemporary new creations in the style of archaic or classical models, did not do this primarily just to admire the piece of art. No, the educated Roman joined all of these items in the rooms of his house and in the extensive gardens into something completely new, with altered functions and new ways of understanding. While the statues and paintings of gods, heroes, or statesmen in Greece were given as votive gifts in temples, or set up as honorary statues in marketplaces and other public areas, in other words fulfilled a religious or social role, the Roman aristocrat liked to create a cultural horizon that was based on the appeal of scholarly association and one which he proudly presented to his learned guests.

217 and 216 BCE — Ruinous defeats of the Romans by Hannibal at Lake Trasimene and Cannae

212 BCE — Roman conquest of Syracuse, where the mathematician and inventor Archimedes meets his death

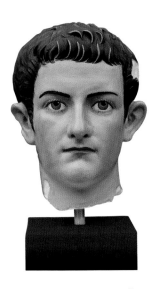
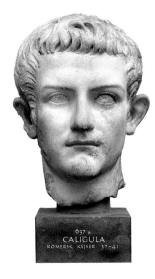

7 8

7. COLOUR RECONSTRUCTION OF THE CALIGULA PORTRAIT
Imitation marble, height 30 cm
Munich, Stiftung Archäologie

8. PORTRAIT HEAD OF EMPEROR CALIGULA
37–41 CE, marble, height 30 cm
Copenhagen, Ny Carlsberg Glyptotek

9. PORTRAIT OF AUGUSTUS
1st half of the 1st century CE, glass, height 4.9 cm
Cologne, Römisch-Germanisches Museum

10. MARKUS AURELIUS RECEIVES HIS DEFEATED BARBARIANS
170–180 CE, marble relief, height 312 cm, width 221 cm
Rome, Musei Capitolini, Palazzo dei Conservatori

Thus likenesses of philosophers did not merely stand in a room as works of famous artists. They were also meant to allude to the philosophical understanding of the master of the house, maybe even to his favoured attitude towards life, be it that of a Stoic or an Epicurean; likenesses of great rulers of the past could on the other hand recall the statesmanlike assets of those depicted, which the owner saw in himself or considered desirable.

The same is true for the bronze hermai from the Villa dei Papiri with the heads of the famous *Doryphoros of Polykleitos* (ill. p. 14) and an Amazon (ill. p. 14), whose original stood in Ephesus: the opposite location in the villa's peristyle did not simply recall the existence of these masterpieces, but surely also the myth of Achilles and the Amazon queen Penthesilea, according to which the hero fell in love with the Amazon at the exact moment he killed her. Thus an individual work signified more in Roman imagery as a rule than just what was immediately represented. The references did not necessarily have to follow a particular programme among themselves. They could rather awaken, amongst the admiring guests, associations with other paintings, thus encouraging many a learned debate. All kinds of eclectic (But is eclectic really the appropriate expression here? Yes, I do think that what was presented was selected and intellectually reassembled,

both from real copies as well as from eclecticizing ones, from different models of newly created statue forms) connotations that classically educated Romans were constantly integrating into the new imagery were possible like this. However, all this always took place in light of the Greek world of imagery with its unimpeachable classical authority, for which there was no alternative. Nor was an alternative needed, because the Romans considered themselves the successors of the Greeks, and Greek culture was considered the common inheritance of the civilized world. Thus Cicero called his garden *gymnasium* or *academia,* whereby he basically brought a piece of Greece into his own home.

augustan classical style

In this interpretation lay a great chance for the founder of the Roman Empire. Augustus had the opportunity to start something completely new, to use it as a consciously chosen picture language to secure his rule and as an instrument to change people's mindsets. Previously, during the confusion of the Civil War with its gruelling power struggles and constantly changing positions, none of the pro-

211 BCE — Hannibal appears outside the gates of Rome, without however attacking the city
197 BCE — The Romans are victorious at Cynoscephalae against King Philip V of Macedon

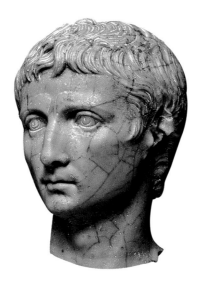

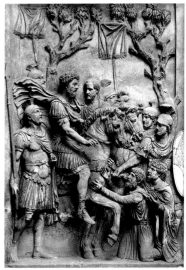

9

10

"Now Judas had heard of the Romans, that they were mighty and valiant men, and such as would lovingly accept all that joined themselves unto them, and make a league of amity with all that came unto them …"

1 Maccabees 8:1

tagonists was even remotely successful at establishing his own portrait as a standard of official portraiture. Augustus on the other hand had become the sole ruler after his victory over Mark Antony and Cleopatra at the naval battle of Actium in 31 BCE. He knew how to use this position in an ingenious way for his portrait policy. His official portrait was to serve as the prime example. It shows how a binding conception created at the court of the Princeps could become the imagery of power.

More than 250 likenesses in three styles ranging from young Octavian to a more mature Augustus have come down to us. The miniature portrait from Cologne (ill. p. 13) with its turquoise glass overlay is an example of the so-called Prima Porta or main type. In contrast to the earlier likenesses still bound to the Hellenistic pathos, what we have here, idealized, is the "august one": he received the title "Augustus" in 27 BCE. The face appears youthfully slender, the narrow mouth is slightly open and the hair on his forehead is arranged in a characteristic fork-and-tongs motif. It is this hair motif that is basically the decisive identifying factor of every Augustus portrait of this type.

The imagery for his likenesses was borrowed from Greek classical art, or more specifically from the likenesses by the classical artist par excellence: Polykleitos. Whether as a pious citizen in a toga, or as

a successful military commander in armour or on horseback, Augustus was always depicted as confident and calm, and for that matter, as ageless. The likenesses of the 40-year-old were hardly any different from those of Augustus as a 70-year-old, a habit still preserved by autocrats and dictators who always want to appear energetic and in full possession of their powers.

The reality also looked different for Augustus. The biographer Suetonius reports that the Princeps, who was 1.70 m tall, did indeed have bright, shining eyes in which some even saw divine power, but small and rotten teeth with many gaps between them were definitely not part of the image of a perfect emperor. In addition his body was "so covered with spots and moles on his breast and stomach that their form, arrangement, and number formed the constellation of Ursa Major. He also had many calluses resembling ringworm, which had formed because of his constant and exaggerated use of the strigil for his itchy skin." (Suetonius, Aug. LXXX) In addition he limped because of shortened bones on the left side of his body and his health clearly left something to be desired.

All these physical shortcomings and blemishes were banned and erased from the official representations of the man who after the battle of Actium had his own victory goddess (ill. p. 10) erected in the

181 BCE — The first gilded statue of a mortal is erected in Rome
146 BCE — Carthage is completely destroyed after the Third Punic War; Rome conquers and destroys Corinth

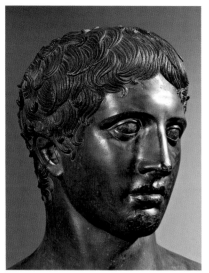

11. HERMA WITH HEAD REPLICA OF DORYPHOROS BY POLYKLEITOS FROM THE 5th CENTURY BCE
c. 30 BCE, bronze, height 54 cm,
from the Villa dei Papiri, Herculaneum
Naples, Museo Archeologico Nazionale

12. HERMA WITH HEAD REPLICA OF AN AMAZON STATUE OF THE 5th CENTURY BCE
c. 30 BCE, bronze,
from the Villa dei Papiri, Herculaneum
Naples, Museo Archeologico Nazionale

13. TIBERIUS BEFORE THE DEIFIED AUGUSTUS (GRAND CAMÉE DE FRANCE)
after 14 CE, sardonyx, 31 x 26.5 cm
Paris, Bibliothèque National

11

12

Curia, in the Senate's meeting place, and who, with this military success, created the foundation for the Pax Augusta, the much longed-for peace throughout the entire Roman world. The motif of Victoria subsequently became a universally valid image of ruler-symbolism.

Augustus prudently avoided openly demonstrating his power or arousing the people's disfavour through a display of excessive luxury in everyday life or during festivals. However, Augustus and his family, as well as his closest friends and advisers, developed into trendsetters when it came to appearance, fashion, or taste in art. His residence on the Palatine Hill – a conglomerate of several houses – was by no means a palace in the later sense, but it definitely was not humble, as is proved by excavated remains. It was only later rulers who covered the Palatine and other locations with building complexes we would now call palaces: two examples are Nero's *Domus Aurea,* his "Golden House", and Hadrian's Villa at Tivoli. The house of Augustus derived its uniqueness compared with other patrician villas in Rome and elsewhere from its location and of course from its owner. He lived in the vicinity of the hut in which Romulus was said to have lived, as well as close to the temple he had had erected for his patron god Apollo. In the sanctum of the temple of Apollo Augustus united three original god statues by different famous Greek artists from the 4th century

BCE into a new cult image group: the Apollo by Scopas, the Artemis by Timoteus, and the Leto, the mother of the two siblings, by Cephisodotus (ill. p. 18). This is the earliest known case where original Greek statues were brought to Rome to be reused as cult images.

Worshipping the Princeps as god-like or even as divine was not customary in the early days of the Empire or only occurred cautiously. Augustus opposed a direct cult of his own person in Rome for example, by having some 80 silver statues melted down that had been erected in his honour. He used some of the proceeds from these melted-down statues to consecrate golden tripods to the Palatine Apollo. In contrast, Augustus did permit his person to be worshipped as divine in the Hellenistic east, where however deification of the ruler was part of the contemporary, traditional religious and social custom – but only in one temple of Roma together with the likeness of the state goddess; in later years this Roman-republican taboo was frequently broken. Augustus did however demand the indirect worship of his person by combining the worship of the Roman household deities, the lares, with that of his genius, the *Genius Augusti;* with this arrangement of the imperial cult he was particularly able to reach the lower social classes and the freedmen, whose loyalty to the ruling family was known to be important.

133 BCE — Attalus III of Pergamon bequeaths his kingdom to Rome

82–79 BCE — Sulla's dictatorship

before 100 BCE — The Villa dei Misteri is built in Pompeii

73–71 BCE — Slave rebellion under Spartacus

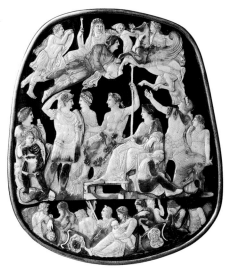

"There was an onyx on which a group was carved in the customary semi-embossed manner. A man was sitting in an ancient chair. He was only scantily clad. His arms were resting very plainly by his side and his dignified countenance was only elevated a little. … women, men, and youths were standing sideways and less strongly raised, a goddess was holding a wreath over the seated man's head. My father said … the seated man could well be Augustus."

Adalbert Stifter on the Gemma Augustea, in: Der Nachsommer, 1857

13

Pictorial Propaganda for the Emperor Myth

In contrast to the public sphere, allusions placing the Princeps close to Roman deities or heroes could be formulated in pictures within the inner circle of the imperial family or in the upper ruling classes. Such allusions were altogether customary in courtly verse composition. One suitable medium were for example precious intaglios and cameos. These cut (semi-precious) stones with their unmistakable representations were a propaganda medium for the emperor myth much esteemed by the rulers; but dignitaries also commissioned them to demonstrate their loyalty to the imperial family. Such a glorification of Tiberius (reg. 14–37 CE) can be seen on the so-called *Grand Camée de France* (ill. p. 15): Tiberius is seated on a throne – like his adoptive father on the famous *Gemma Augustea* – next to his deified mother Livia, surrounded by princes with their wives. The lower part of the picture shows subjected barbarians, while at the top the deified Augustus of Aion, the genius of eternity, is lifted up, accompanied by two already deceased princes. The small boy in the soldier's costume in the left of the picture is the future emperor Caligula (reg. 37–41 CE). Neither this picture nor his portrait (ill. p. 12) give any suggestion of his future atrocities. This portrait's original coloration was re-constructed from surviving traces of colour (ill. p. 12). Once again we will have to get used to the fact that all Roman marble works were coloured, as was the case with the Greeks.

This is of course also true of the statue of Emperor Claudius (reg. 41–54 CE) with oak wreath and sceptre, which shows him in the pose of Jupiter, Rome's supreme patron god (ill. p. 25). His upper body is bare, while his lower body is wrapped in a heavy cloak thrown over the left shoulder in the manner typical of the time. The emperor's appearance is majestic. He only ascended the throne at 51 years of age. Until then he had been leading the life of a scholar. His body is athletic. It is an ideal representation of the ruler as was intended to be seen by the populace. There is nothing here to remind us of the words of his critics, who accused him of being a stay-at-home and blamed his weak physique on this habit. In addition they ridiculed his shyness and speech impediment.

Just as emperors presented an ideal of themselves, people of lower classes also tried to document their ideal concepts through pictures. A group that has only come into the focus of art history during recent decades is that of the freedmen, those who had bought themselves out of slavery or were manumitted. Although they became citizens, they were only second class. However, their abilities made a fair

58 BCE — Caesar writes "De bello gallico", the report of his conquest of Gaul | 49–45 BCE — Civil war
49 BCE — Caesar crosses the Rubicon | 48–47 BCE — Caesar and Cleopatra in Egypt together

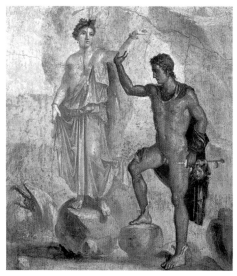

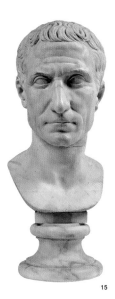

14 15

proportion of them affluent or even extremely rich. This is demonstrated by many an exuberant tomb. They may have worked as bakers, builders, or bankers – and often also as the stooge of their former master. The people who acquired Roman citizenship this way were particularly keen to distinguish themselves as Romans in society. They aspired to offices and honours open to freedmen – such as becoming a member of the *seviri Augustales* who were responsible for the imperial cult; they were also entitled to a special seat in the theatre. Freedmen also made sure they could be identified as Roman citizens on their tombstones. One relief (ill. p. 20) for example shows the deceased as a low-ranking officer whose courage and valour is expressed by the Greek pictorial formula of "nudity", while his parents and other relatives are represented in plain clothes. Sequences with portrait statues of family members were also customary for the imperial family, for example in theatres, in baths, or in other areas of public life.

Such statue ensembles that we know from many places of the Roman Empire attested to the loyalty of the benefactors – whether private citizens or communities – to the ruling household. At the same time they were a symbol of the cohesion of the imperial family and the people – a statement that of course by no means always corresponded to reality, but was part of the orthodoxy of principate ideology.

The so-called state reliefs, or historical reliefs as they used to be called, are surely amongst the most impressive bearers and preservers of the ruler ideology. These usually large-sized reliefs addressing scenes of war and peace, as well as other subjects taken from political life, are amongst the characteristic monument genres of Roman art. It is not that there had not been political art before – the Egyptians, Greeks, Persians, and the Hellenistic kingdoms all made use of it, but after Augustus the Romans perfected this kind of political monumental art explicitly to glorify the emperor and otherwise important men.

The state reliefs were not works that stood in isolation, no, they were part of political monuments such as altars or (more rarely) temples, triumphal columns and arches, which they both decorated and explained. The dimensions and location on the object were not prescribed by architectural orders, as was the case with the Greek temple with its canonical metope fields and friezes. Marble was the correct and representative stone. It was not for nothing that Augustus claimed that he had found a city built of brick and left one of marble (Suetonius, Aug. XXVIII).

Besides the *Ara Pacis Augustae, Trajan's Column,* and other famous state reliefs, the three panels on an arch of Marcus Aurelius (reg. 161–180 CE) in the Palazzo dei Conservatori, which are more

44 BCE — Carthage is re-founded by Caesar; Caesar is assassinated
before 27 BCE — Erection of the tomb of Caecilia Metella on the Via Appia

14. PERSEUS FREES ANDROMEDA
early imperial period, wall painting from the Casa
dei Dioscuri in Pompeii, height 128 cm, width 98 cm
Naples, Museo Archeologico Nazionale

15. PORTRAIT OF GAIUS JULIUS CAESAR,
SO-CALLED CAESAR CHIARAMONTI
27–20 BCE, marble, height of the head 26 cm
Rome, Musei Vaticani, Museo Chiaramonti

16. PORTRAIT OF EMPEROR CARACALLA
211–217 CE, marble, height 34 cm
Copenhagen, Ny Carlsberg Glyptotek

17. PORTRAIT HEAD OF GNEAUS
POMPEIUS MAGNUS (POMPEY)
c. 55 BCE, marble, height 25 cm
Copenhagen, Ny Carlsberg Glyptotek

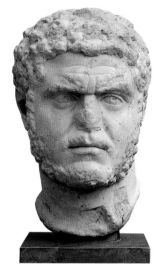

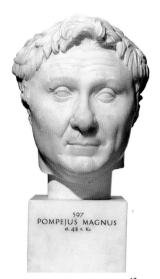

16 17

than three metres high and two metres wide, are among the most significant testimonials of Roman relief art. Eight further panels of this no-longer surviving monument, which was probably erected in 176 CE for the occasion of Aurelius' triumph over the Sarmatians and the Germans, were later taken and used for the arch of Constantine the Great. One of the panels (ill. p. 13) shows Marcus Aurelius on a horse, riding through an oak forest, accompanied by his retinue. Two gnarled tree trunks suffice to indicate the forest, two flag-like military standards stand for the cavalry – it is a brief and concise artistic setting of the "stage". The emperor has a long beard, which suited the "philosopher on the emperor's throne" – as Marcus Aurelius is also called – very well. This new ruler image together with curly hair had been introduced by his philhellene predecessor, Hadrian (reg. 117–138 CE). The portrait's forcefulness was heightened by the curls from his head to his beard, whose chiaroscuro effect forms a strong contrast to the smoothness of the skin. Soldiers are presenting two defeated barbarian princes to Marcus Aurelius. The princes are prostrating themselves in front of him, pleading for clemency. The victor will grant it to them, he lets them experience his *clementia,* his mercy. The other two panels depict the emperor in his triumphal quadriga and during his thanksgiving sacrifice to Iupiter Capitolinus.

These and comparable scenes were not so much intended to faithfully record concrete historical events as to celebrate the general ruler-ideal with its role-models. Thus it was possible for gods to intervene in the events or for mythical heroes to accompany the Princeps on such state reliefs. They did not refer to a particular victory, a particular victim, or a particular subjugation gesture. These images translated certain of the emperor's virtues into a picture language that was understood throughout the empire – in Britain as well as in Egypt, in Spain as well as in Greece. Military victory stood for *virtus,* voluntary submission by the enemies for mercy, *clementia,* the sacrifice for piety and religious obligation, *pietas.* Even for Augustus these qualities had already been amongst the cardinal virtues of a good ruler who also dispensed justice, *iustitia.* Again it was the first Princeps who firmly entrenched such virtues in the ruler ideology of the Roman emperors. In his account of his accomplishments, the *Res Gestae,* Augustus reported that the senate and people of Rome had had a golden shield, the *clipeus virtutis,* erected for him in the Curia Iulia. Its inscription, which has come down to us, names precisely these pious and patriotic qualities: *virtus, clementia, iustitia, pietas.*

27 BCE — Octavian receives the honorary title Augustus 12–9 BCE — Large parts of Germania are conquered
9 CE — Battle of the Teutoburg Forest: the Germanic Cherusci chieftain Arminius defeats Varus' legions

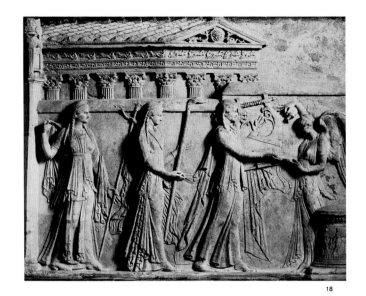

18

"Much threatened and disrupted by the power struggles of the 'soldier emperors' and the incipient 'barbarian invasions', the empire loses shine and statuary portrait commissions, quite apart from the fact that the inner need to produce and display such likenesses falls away. Plazas and roads that had contained hundreds of portrait statues for 300–400 years are now almost empty."

Ernst Buschor, 1947

Art for Emperor and Empire

Propagandizing these virtues of Augustus was just as current in Marcus Aurelius' time as it was in that of his successors. Of course there were also other standardized representation formulae, such as the act of going to war (the *profectio*), the emperor's speech to his army (the *adlocutio*), the return of the victors (the *adventus*), the distribution of money or other gifts to the people (the *congiarium*). Thus sculptors' workshops, commissioned by the rulers, shaped models that were prerequisites for the creation of an art of the empire. Once again the imagery derived from the pool of Greek art. This classicism supported the robustly cohesive political and social system of principate ideology for more than two centuries. A change did not seem necessary, there was a high degree of standardization, but the downside of such a system was that innovative elements were missing.

Marcus Aurelius was the last great ruler from the group of "adoptive emperors" that followed the Flavian dynasty, who for their part had succeeded the Julio-Claudian house. Rome lost a good ruler in the "philosopher on the emperor's throne", who had also been very successful in his military dealings. The wellbeing of the Roman Empire and its people had been his life's task. His son Commodus (reg.

180–192 CE) on the other hand, who took over the highest office at age 18, considered the empire simply as his father's legacy and thus as his personal property. The young emperor did not think much of "duty" as a ruler-virtue. He demoted his father's advisors to the status of subordinates. He considered their advice to be mere tutelage. A wind of change started to blow through the office of Principate. Commodus had himself presented to the senate as a living god and as the reincarnation of Hercules. In the confusion around who would become emperor after Commodus was assassinated, the African Septimius Severus (reg. 193–211 CE) was able to assert himself. He was a military man. The fact that the empire's borders were coming increasingly under threat also contributed to the army's playing an ever larger role when it came to emperors securing their position.

This change can also be seen in the emperor portraits of the time. Caracalla, who had had his brother assassinated so that he could rule the empire alone, had many of the qualities that marked a bad Princeps. It is almost possible to recognize these character traits in his portrait (ill. p. 17). Beholders do not look into the countenance of a mild, wise, and just ruler. Caracalla broke with this idea of the aristocratic and noble first citizen of the state, and had himself depicted with unkempt hair and beard, which framed a face with gloomy and grim

60–63 CE — Paul the Apostle preaches in Rome 64 CE — Rome in flames, Emperor Nero is thought to be the arsonist
67 CE — The apostles Peter and Paul are put to death

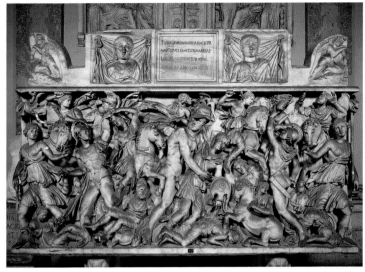

18. ARCHAICIZING RELIEF WITH APOLLO, ARTEMIS, LETO AND NIKE AT A SACRIFICE
Augustan period, marble
Rome, Galleria Albani e collezione archeologico

19. SARCOPHAGUS WITH AMAZON BATTLE (ACHILLES AND PENTHESILEA)
c. 240 CE, marble, length 251 cm, height 117 cm, width 110 cm
Rome, Musei Vaticani

19

gaze. That is exactly how he wanted to be seen and feared: his angry visage was supposed to intimidate everyone. Nothing in this portrait points to his role model Alexander the Great, whom he sought to emulate and whose successor he considered himself to be. Here someone had changed the likeness of a heroic world ruler for that of a grim, absolutely determined soldier – the era of soldier emperors had begun. These emperors were only able to take the throne with the help of the army and once there they could only hold on to it for a more or less short period of time.

Private death Portraits

When looking at the portraits of individuals that have survived from Roman times, which are most commonly made of marble and other types of stone, and more rarely of bronze and even more rarely of precious metals such as gold and silver, it is easy to forget that there were also other media available for producing portrait effigies: it is just that compared with the marble sculptures hardly any of these effigies have survived through the ages. Painting is the main medium that should be mentioned here.

The odd portrait has remained from the wall paintings in the towns destroyed by Mount Vesuvius, Pompeii and Herculaneum, but the large majority of panels have been lost forever. It would be great to be able to admire a work by Apelles, who, as the court painter of Alexander the Great, travelled through Egypt with the world conqueror. A great stroke of luck that somewhat softens the blow of losing ancient portrait and panel paintings is the preservation of the mummy likenesses from Egypt's oases, particularly those from Al Fayyum. The earliest mummy portraits were created from the first half of the 1st century BCE, in what was a melting pot for a multi-cultural society made up of Egyptians, Greeks, Asians and others, which surely became yet more international after 31 BCE when Egypt became a Roman province and had to integrate very different customs and conventions. This new custom, away from the traditional mummy mask towards an image of the deceased painted on wood or canvas, may also be linked to the fact that, in the wake of Egypt's conquest by the Greeks under Alexander the Great and particularly then by the Romans, the entire death cult of the Egyptian population, which was after all connected to the universe as it was represented by the pharaoh, was shaken in its credibility. Many of the people immortalized or rather remembered on the wood panels were presumably members

79 CE — Mount Vesuvius erupts, Pompeii and Herculaneum are destroyed
after 81 CE — Reliefs on the Arch of Titus in the Forum Romanum
80 CE — Inauguration of the Colosseum

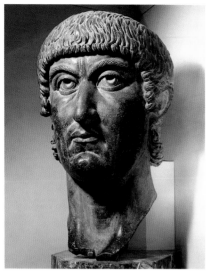

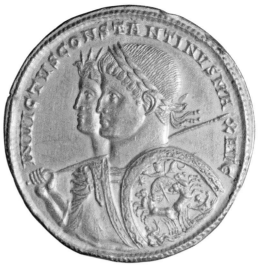

22 23

Maximian lived in Milan and dealt with Italy, Raetia, Africa, and the western isles.

 While the system of empire division was good in theory and although it worked initially, it was not long until rivalries developed amongst the successors. In the end the son of Constantius, Constantine the Great (reg. 306–337 CE) emerged as the victor from these confrontations. Constantine and the developments he initiated changed the Roman world as lastingly as maybe only Augustus had done before him. His victory at the Milvian Bridge in 312 CE over his opponent Maxentius which, by his own testimony, he owed to the god of the Christians, opened the door for Christianity to become the state religion. With the inauguration of Constantinople, the new capital (modern-day Istanbul), on the site of the Greek city of Byzantium on 11th May 330 CE he basically already completed the division of the empire into a Latin West with its capital in Rome, and a Greek East with the new capital located on the border between Europe and Asia.

 On the one hand Constantine's decisions pointed towards a new future, on the other hand he recalled predecessors who had gone down in Rome's annals as good emperors, such as Trajan or Marcus Aurelius. Thus, both are reflected in the portrait of the ruler, such as the over-life-sized bronze head that was once part of a monumental statue (ill. p. 22). The short beard and the close-cropped head-hair of the solider emperors as well as the grim face of the military man willing to do anything made way for a different understanding of the Princeps: the thick head of hair recalls the portrait of the beardless Trajan, thick brows emphasize the big eyes that seem to peer over the observer far into the distance. The facial traits are more classically calm again. The thoughtfulness and internalization of late-Antiquity man seem to emanate from the portrait, which was probably made during the last years of his reign.

 Constantine's bronze head is one of the rare examples of bronze likenesses that have survived to this day. Their one-time number in Rome alone must have been very large despite all the officially ordered purges and the many devastations that occurred. An inventory made by Zacharias, a rhetorician and bishop of Mytilene, for the city of Rome, apparently after the devastation by the Ostrogoth Totila in 546 CE, gives an idea of the comprehensive loss of this category in the monument stock. He only lists bronze statues of emperors and military commanders located outdoors and he came to a stately number: two colossi (such as the above-mentioned Constantine), 22 colossal equestrian statues (such as the one of Marcus Aurelius on the Capitoline Hill), and 3785 portrait statues; the effigy statues made of

212–217 CE — The baths of Caracalla are built in Rome 247 CE — Games held in Rome
in honour of the city's millennium after 300 CE — Construction of Diocletian's Palace in modern Split (Croatia)

**22. COLOSSAL HEAD OF
CONSTANTINE THE GREAT**
c. 335 CE or later, bronze, height 185 cm
Rome, Musei Capitolini, Palazzo dei Conservatori

**23. MEDALLION WITH EMPEROR
CONSTANTINE THE GREAT AND
THE SUN GOD SOL**
313 CE, gold
Paris, Cabinet des Médailles

**24. MUMMY PORTRAIT OF
AN ADOLESCENT**
1st half of the 3rd century CE,
tempera on wood, 38 x 19 x 0.3 cm
London, The British Museum

**25. YOUNG ATHLETIC GIRLS AT
SPORT (SO-CALLED BIKINI-GIRLS)**
4th century CE, detail from a mosaic in the Villa
Romana del Casale near Piazza Armerina, Sicily

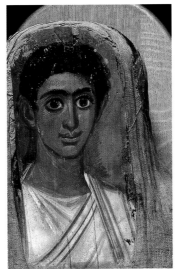

24

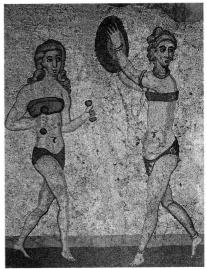

25

gold and silver which we know from written sources and from a few fragments remained unmentioned. According to the latest research, 15 bronze likenesses that almost certainly came from Rome have survived.

What fates the ancient large bronzes could suffer, besides destruction by conquerors and fanatical Christians or melting down for weapons and tools, is illustrated by the verses of Juvenal (Iuv. Sat. 10, 56–66) on the end of Emperor Tiberius' praetorian prefect Sejanus: "Some are brought to their knees by the abundance of power that creates great envy; downfall comes to them because of their long list of honours and distinctions: statues leave their pedestals: they are pulled down with ropes, axes are used to break the wheels on the victor's chariot, and the innocent horses have their legs broken. The flames are blazing high: the head the people once worshipped is already glowing in the bellows and in chimneys; the great Sejanus has come crashing down. The countenance that was once second in the world is being melted down into jugs and bowls, pans and chamber pots."

We have seen pictures and scenes of toppled statues of hated dictators in our times, such as the toppling of the statue of Saddam Hussein from its pedestal in Baghdad in 2003.

The likenesses of Constantine the Great were largely spared such a fate. He was considered a good emperor and well-wisher of Christianity. A gold medallion (ill. p. 22), coined especially for the Edict of Milan which gave Christians religious tolerance in 313 CE, shows that Constantine's support of Christianity in no sense went over the heads of the pantheon of old Roman deities. Interestingly, the obverse of the medallion shows the bust of Constantine dressed in military armour and with a diadem-like laurel wreath; with his right hand he is shouldering a spear, in his left hand he is holding a richly ornamented round shield displaying the quadriga of the sun god; on the ground are Tellus and Oceanus, i.e. the personifications of Earth and the ocean ruled by Rome, above them are the crescent moon and a star. Behind Constantine's bust we can see the sun god Sol himself, wearing a crown of rays.

This again makes it clear that even after his victory in 312 CE, Constantine did not initially want to rely on the Christian god alone to secure his power and to legitimize his position as sole ruler. However, he no longer had to keep up the fiction that the principate set up by Emperor Augustus was not a monarchy. The tetrarchs had already begun clearly distancing their own likenesses from representations of other dignitaries of the empire or even private individuals by introduc-

312 CE — The Battle at the Milvian Bridge ends with the victory of Constantine
312 CE — Construction of the Basilica of St. John Lateran, the main church of the Christian world

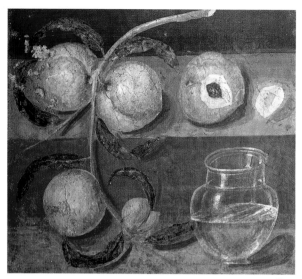

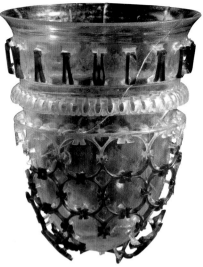

26

27

ing elements of regalia. These included belts, sandals, and weapons richly studded with jewels as well as an exuberant use of purple garments. Constantine trumped all of this. He added to the jewels that until then had been the marks of the unpopular oriental rulers by re-introducing the royal diadem in 324/325 CE. Under Augustus and his successors such a symbol of Hellenistic kingship as an unmistakable sign to the claim of sole rule would have been unthinkable. The Romans had seen this cloth band with its hanging ends in the nape of the neck with their own eyes on Cleopatra in her city and Caesar was well advised to reject it when Mark Antony publicly offered it to him. On Constantine's coins this diadem is clearly shown in this form and soon it would appear studded with pearls and jewels. The further development of this regal insignia led to a rigid, jewel-studded band and finally to the Byzantine imperial crown.

It was not just the ever more magnificent items of the regalia, the rooms fitted with rare marble varieties, or valuable cups and plates made of gold, silver or glass for the table of the emperor as well as rich and high-standing dignitaries, such as a cage cup made from an elaborately worked multi-coloured glass block (ill. p. 24), that continued to increase the gap between the ruler and the people. Mosaics, ivory carvings, and other artworks dating from late Antiquity give an impression of this and document the changed world the people lived in. The court rituals became ever more sophisticated and contrived. Now the adoration *(adoratio)* and the worship of the emperor on one's knees *(proskynesis)* as well as ritual silences were demanded of the people. This created a very different image from the beginnings of the principate. For Augustus and his successors it had still been a concern and necessary for their own position of power to communicate directly with the senate and the people. However, this contact was deliberately interrupted in the 4th century. More and more, the emperor was not considered a self-made powerful individual so much as someone called by God to do His work. This meant criticism of the ruler was no longer possible.

The Fall of the Western Empire

The army remained an important pillar for securing the emperor's rule. The separation of the civil and military commands and the simultaneous creation of the office of *magister militum* (master of the soldiers) by Constantine permitted purely military careers. These positions however also promoted a particularly close and thus powerful

313 CE — The Edict of Milan guarantees religious freedom to Christians

324 CE — Founding of Constantinople

325 CE — Council of Nicaea

330 CE — Inauguration of Constantinople as the new capital of the empire

26. STILL-LIFE WITH PEACH SPRIG AND GLASS JUG
1st/2nd century CE, fresco
Naples, Museo Archeologico Nazionale

27. CAGE CUP
1st half of the 4th century CE,
glass, height 12.1cm
Cologne, Römisch Germanisches
Museum

28. STATUE OF THE EMPEROR CLAUDIUS AS JUPITER
after 41 CE, marble, height 254 cm
Rome, Musei Vaticani

29. DIPTYCH OF EUCHERIUS WITH HIS PARENTS STILICHO AND SERENA
c. 396 CE, ivory
Monza, Museo del Duomo,
Basilica di San Giovanni Battista

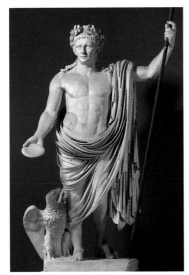

28

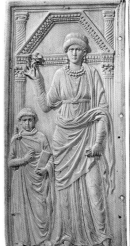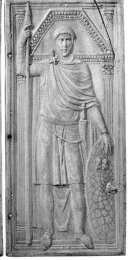

29

relationship between the troops and their commander. More and more Germanic people attained these positions so that it would not be incorrect to speak of a creeping Germanization of the army. One man who made it a long way in the office of *magister militum* and also acted successfully as a military commander was the Vandal Flavius Stilicho (in office 395–408 CE). He was close to Theodosius I (reg. 378–395 CE) and was even married to his niece Serena. Thus, although he was a "barbarian" he was an immediate member of the imperial family. Stilicho is represented on an ivory diptych together with his wife and their son Eucherius (ill. p. 25). This double panel was originally held together by strings and was probably meant to announce to the recipient that Stilicho's son was going to take over an office, since Eucherius was holding such a diptych himself. He is standing next to his mother who is dressed in a sumptuous gown and wearing valuable jewellery; she is holding a rose in her right hand. The other panel shows Stilicho in his military dress. His belt and scabbard must have been richly ornamented with jewels, and the military cloak, decorated with circular ornaments, was held together with a valuable clasp at his shoulder. He is holding a spear in his right hand, while his left hand is resting on a shield; the two imperial busts on it portray Stilicho's power position as the protector of his master. The diptych's

imagery was still clearly Greek. However, this would not stay that way for long because, with the rise of other rulers to Roman offices during the barbarian invasion period, new artistic styles also developed.

Greed for power, envy and the arbitrariness of offices finally sealed the fate of Stilicho and his family. He was killed in Ravenna in 408 CE. His son Eucherius was murdered in Rome and his wife was executed for allegedly committing high treason. The king of the Visigoths, Alaric, who styled himself Stilicho's avenger, plundered Rome in 410 CE; together with the Visigoths, the Roman *magister militum* Aetius managed to subdue Attila and the Huns. However, in the end the fall of the Western Empire could no longer be stopped. In 476 CE the last emperor in Rome was deposed. His name was Romulus Augustulus – an irony of world history: the last emperor bore the name of the founder of the city, Romulus, and the first emperor, Augustus.

391 CE — Emperor Theodosius I makes Christianity the state religion, all pagan cults are prohibited

410 CE — The Visigoths conquer Rome under Alaric 476 CE — End of the Western Empire

The capitoline wolf (Lupa capitolina)

Bronze, height 75 cm, length 114 cm
Rome, Musei Capitolini, Palazzo dei Conservatori

The bronze effigy of the she-wolf is not only the venerable emblem of Rome. It is also one of the most striking animal sculptures to have survived from Antiquity. Its story is long, but surprisingly it was almost unknown during ancient times. It is likely that it originally stood in a temple, perhaps in one dedicated to Mars, the god of war, since wolves were sacred to him. We also know of a she-wolf at the Lupercal, a time-honoured wolf cave on the Palatine Hill, as well as one on the Capitoline. Since the 10th century at least the *Lupa Capitolina* was located at the Lateran Palace where Dante saw it around 1300. In 1471 the bronze she-wolf was brought to the Capitoline. No later than 1510 the twin boys were added. They were probably works by Antonio del Pollaiuolo (1432?–1498). The statue has been in its current location since 1921.

Originally, to emphasize this fact again, the twin boys were not part of the sculpture, even though the motif of the two small children Romulus and Remus being suckled by the she-wolf of Roman art was certainly familiar.

As if ready to defend herself she has stemmed her front legs firmly on the ground, has slightly lowered her head, has vigilantly pricked up her ears, and is showing her formidable canine teeth to her attacker; originally her tongue was also hanging out. The carefully arranged curls at the neck and the curls that frame the head are more reminiscent of a lion's mane than of the bristling fur of a she-wolf. She is surely portrayed as a mother feeding and protecting her young, as is indicated by the eight swollen teats.

The *Lupa* is not the work of a Greek sculptor. It was cast in an Italian, probably Etruscan, workshop. Despite the formal elements that recall Etruscan clay sculptures, the influences of Greek art cannot be denied, a fact which is hardly surprising during the first years of the 5th century BCE. The Capitoline Wolf is still considered the emblem of the city of Rome as well as the embodiment of the founding legend in which a she-wolf played a crucial part. According to the legend, the daughter of the rightful king of Alba Longa, Rhea Silvia, was impregnated by Mars and subsequently gave birth to the twins Romulus and Remus. To rid himself of the potential heirs to the throne, the king's brother and usurper of the crown had the two abandoned in the Tiber. There however they were rescued by a she-wolf who got them out of the water and suckled them until the shepherd Faustulus found them and took them in. In the end Romulus founded the city of Rome on 21st April 753 BCE. Of course this date is just as fictitious as the founding legend itself. In ancient Rome, however, this story was considered to be the historical account and has been known in the literature and visual arts since the 3rd century BCE – in other words a time when it must have been very useful to the Romans to be able to provide the Greeks with a founding legend that was intertwined with their myths through the god of war, Mars, and the progenitor of the Roman people, the Trojan Aeneas, because it was at this time that the Roman Empire began expanding towards the eastern Mediterranean. The notion that the Capitoline Wolf is to be identified with the one at the old wolf cave on the Palatine under whose teats effigies of Romulus and

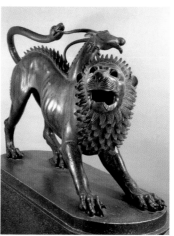

Chimera of Arezzo, Etruscan, early 4th century BCE

Remus were placed in 295 BCE is just as unlikely as the story itself. However, here we can console ourselves with Goethe, who said to Eckermann on 15th October 1825: "But what should we do with such a paltry truth! And if the Romans were great enough to compose such a story, we at least should be big enough to believe in it."

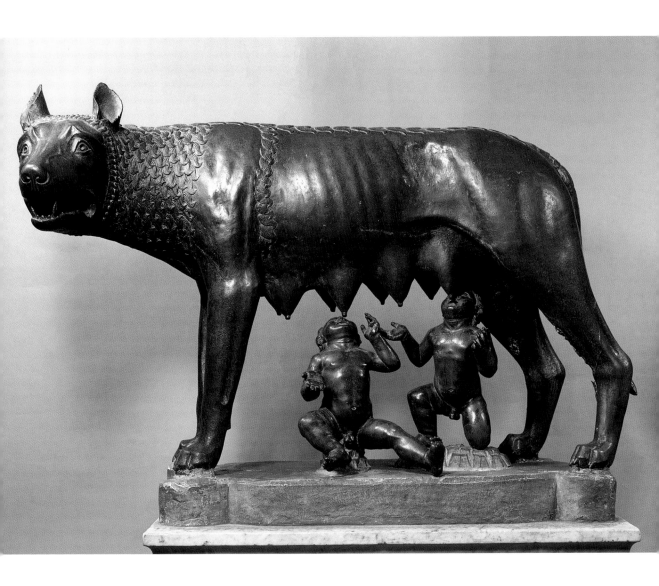

Portrait of an unknown man, so-called Brutus

Bronze, height 32 cm, height with Renaissance-period bust 69 cm
Rome, Musei Capitolini, Palazzo dei Conservatori

===

Already the Dutch artist Marten van Heemskerck drew this impressive bronze bust while he was in Rome during his trip to Italy (1532–1536). It is one of the rare examples of artworks dating to the earlier years of the Roman republic. Originally the portrait was part of an over-life-sized bronze statue that showed the man from a slightly diagonal perspective, his head turned to the right, his chin raised somewhat. This is the cause of the asymmetries in the representation, such as the right ear being placed lower. The face seems to be that of an older man on which life has left its marks. The prominent eyes under the bushy eyebrows are deep set. The forehead has wrinkles and narrow temples. The cheeks are somewhat gaunt, with clear lines running across them, and the lips are firmly pressed together. The hair on his head and his beard lie close to his face, as if it had been made by a modelling tool that was used when working with terra cotta. The positively piercing look of the original eyes – the eyeballs are made of ivory, the pupils and irises of glass or carnelian – undeniably contributes significantly to the bust's fascinating effect. The desire to identify this effigy with the likeness of Lucius Junius Brutus who expelled the last king of Rome in 509 BCE, founded the republic, and became its first consul, arose quite early on. This portrait suited such a hero of Roman history very well. It splendidly captures the character of a down-to-earth Roman of sterling qualities and expresses courage and austerity at the same time. However, unfortunately we do not know who this portrait really represents and it is not very likely that we shall ever find out. In addition, scholarly research has now discovered that this face displays less the unique traits of an individual than the ideal qualities of a man, which, as a type portrait, follows the models of Attic art of the 4th century BCE, which have been modified by regional style differences and the prevailing taste of the time. The portrait of "Brutus" was once one of the portrait statues that were erected more and more in the city's forum after the late 4th century BCE to honour deserving politicians and successful military commanders; visitors may also have come across such statue benedictions in temples. Their inscriptions would have announced the deeds of the person represented. The figure being honoured may have been shown wearing the Roman toga or dressed as a victorious military man in armour together with his weapons.

The Italian and Roman workshops had close contacts to the Greek art world from very early on; after all, the colonies of the Greek cities in Magna Graecia were basically right on their doorstep. After Rome had expanded its conquests to the south of the Italian boot, ever more magnificent examples of Greek art arrived in the city on the banks of the river Tiber in ever larger quantities. The artworks carried along during the triumphal processions provoked the amazement of the people and promoted the influences of the Greek lifestyle in the state's leading families. The number of Greek sculptures that came to Rome was particularly large, especially after Syracuse on the island of Sicily had been conquered in 211 BCE, followed by Tarentum two years later. These two events significantly accelerated the Hellenization of the Roman upper class.

> "During his third triumphal procession… Pompey had (as part of his booty) a chessboard complete with figures paraded with him, which was made from two different semi-precious stones… additionally, three dining couches, table-ware of gold and gemstones for nine stately dining tables, three golden statues of Minerva, Mars and Apollo, thirty-three pearl wreaths, a four-sided golden mountain with deer, lions and fruits of all kinds…, a grotto of pearls, with a sundial upon it…"
>
> Pliny the Elder, about 77 CE

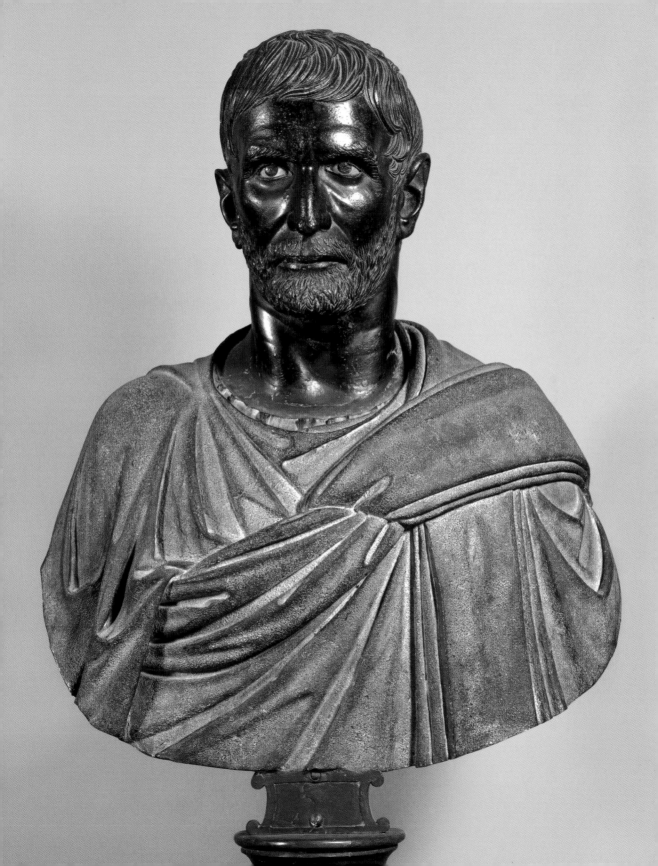

statue of a man, so-called Arringatore

Bronze, height 179 cm
Florence, Museo Archeologico

This life-sized bronze statue was found in the vicinity of Perugia, i.e. in the area once populated by the Etruscans. It was obtained by Cosimo I de' Medici in 1556 and thus came to Florence. The likeness of Aulus Metellus – an Etruscan inscription provides the name of the man depicted – probably came from a temple originally. It would have been set up there by public decree.

We do not know who the Etruscan Aulus Metellus was or what merits he earned. He is shown wearing traditional Roman dress: over the tunic, a kind of shirt, he is wearing a toga, an outer garment made of wool. On his feet he is wearing *calcei,* elaborately laced leather boots. They were a sign of social standing, or the insignia of a person holding public office. The same is true of the ring on the left hand he is holding low down. His right hand is raised in an oratorical gesture.

Whether Aulus Metellus was an Etruscan magistrate or a Roman citizen with Etruscan origins is unclear. The bronze effigy however offers an early example of the statue type called "togatus", a man dressed in a toga, which is probably the best-known form of representation of a typical Roman. This item of clothing distinguished Romans from non-Romans; it was nothing less than a trademark, and it was also a status indicator. Only a Roman citizen was allowed to wear the toga, no foreigner, no slave, nor any inhabitant of the Roman Empire who did not hold Roman citizenship.

The toga was the proper costume for public occasions. Special designs identified the

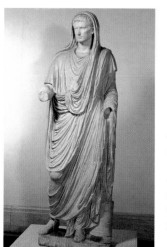

Statue of Augustus sacrificing, from Via Labicana, late 1st century BCE

rank of the "togatus". Thus high magistrates were allowed to wear a purple edge on their toga, generals in their triumphs and consuls were permitted to wear the *toga picta,* a toga that was all purple and embroidered with gold. Comparable distinctions were also made through the tunic's decoration. Member of the equestrian class could be identified by a narrow purple stripe on this garment, while the senators' stripe was correspondingly broader. Aulus Metellus is also wearing a tunic with a stripe to indicate his status.

During the time of the republic, the toga was still cut quite brief, during the early imperial period it started being draped more lavishly. Augustus did not just bring Romans to present themselves as *gens togata,* as a people clad in togas, for official occasions, in the Forum, and in the theatre, he also initiated an even more splendid decoration of the outer garment than had ever been the case before. Thus even the emperor appeared at sacrifices with his head covered by his toga. Unofficially, the Princeps probably did not receive a great amount of approval for this revival of ancient Roman sentiments, since this oval item of clothing which could be up to seven metres in length, was expensive, and tedious to wear. The business of getting dressed was time-consuming and the constantly bent left arm was always occupied with holding the garment. The people that did value the toga highly as a badge of Roman citizenship were the large number of freedmen that lived in Rome during the early imperial period. It may be that they were particularly fond of demonstrating, by wearing the toga in public, the privilege of citizenship they had been awarded; at least they displayed more pride and enthusiasm than the members of the long-established families did. In any case representation in a toga was very popular on one's own grave relief, showing everybody that this was the last resting place of a citizen of Rome.

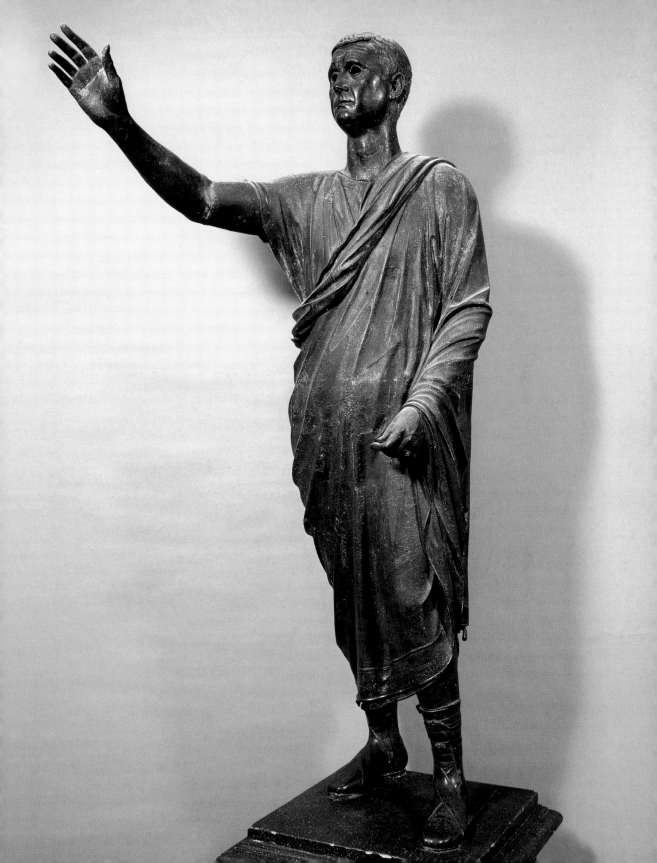

Room with painted architectural elements

Painting on stucco
Rome, Antiquario Palatino

===

The earliest examples of Roman wall painting divided the walls into sections whose appearance was determined by architectural elements. A richly decorated frieze area was located above an orthostat pedestal with rectangular ashlars. Above the frieze were layers that mimicked rectangular brickwork. The upper end of the wall was completed with friezes in Doric or Ionic form, which could have also been supported by half-columns. The joints of the ashlars in the wall stucco were expressed just as three-dimensionally as the frieze decorations were; thus the impression would clearly have been one of standing in front of real brickwork. These often colourfully painted wall decorations imitated models of monumental architecture. The wall composition, which oriented itself on the marble buildings of the classical period for example, was intended to bring these dignified patterns to one's own four walls and thus communicate a grand and dignified feel of the house to its inhabitants and their guests.

How the development progressed can be seen particularly well on the walls of a bedroom in the Casa dei Grifi, whose ceiling was in the form of a barrel vault; this was a new accomplishment of residential architecture of the time. The House of Griffins surely belonged to a member of the late-republican aristocracy who had his living rooms decorated according to the latest trend. Thus the architectural forms are no longer worked as reliefs, but are painted instead. One striking trend was the painting of column bases and columns with Corinthian capitals in front of the elaborately decorated pedestals of the illusionistic ashlar wall that supported a protruding architrave and a coffer roof. This illusion of space in front of the wall decoration itself is what was actually new during those years: the wall appeared to open up, the rooms seemed to have more depth. In order to increase the magnificence some wall panels displayed the veins of alabaster, framed by marble imitations. In the frieze the painters mimicked the valuable porphyry from Egypt and the columns, capitals, and pedestals are also marked by various types of stone.

At the beginning of the 1st century BCE the use of colourful varieties of stone when decorating walls in residential houses was particularly popular amongst Roman senators who, as military commanders or as governors, had come into contact with the culture and luxury of the Greek East. It is no wonder that they were met with criticism and mistrust at home by those who felt committed to Rome's traditional values. It was not done for aristocrats from the old Roman families to furnish their homes with such extravagance, which had previously been reserved for the gods. Even white marble could be seen as an offensive stone, so it is easy to imagine how much more offensive colourful varieties of stone must have been, since even the simplest Roman must have known their exotic origins. Thus houseowners who had their living spaces beautified by having them painted during these years basically killed two birds with one stone: on the one hand the illusionistic architecture with its perspective vistas increased the spatial effect; and on the other hand by imitating precious and expensive colourful varieties of stone it was possible to show off the fashion which was becoming acceptable in polite society, but without getting into the crossfire of public criticism by using the original luxury materials.

> **"It is necessary to determine a certain spot as the point where the eyeline and the other lines converge; we should follow these lines in accordance with a law of nature so that the appearance of buildings is portrayed properly in the picture and that what we imagine on flat surfaces sometimes appears to retreat into the background and sometimes appears to step forward."**
>
> Vitruvius, On Architecture

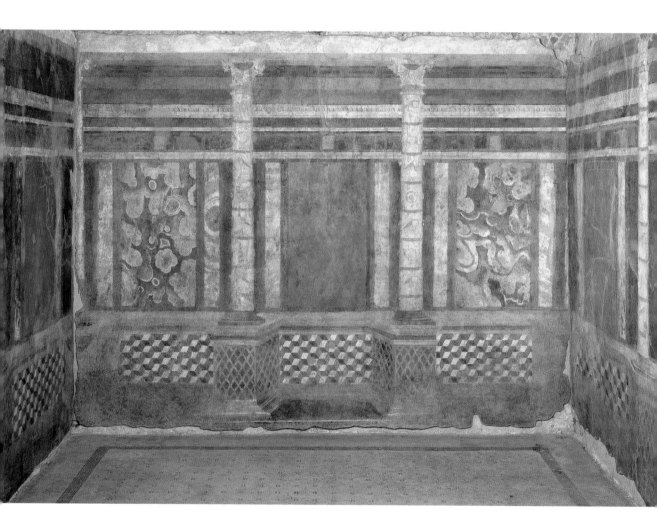

portrait head of cleopatra VII

Marble, height 29.5cm
Berlin, Staatliche Museen zu Berlin – Stiftung Preussischer Kulturbesitz, Antikensammlung

==

There is hardly another woman in world history who captured people's imagination and excited the minds of her contemporaries as much as Cleopatra (69–30 BCE) did. The last Egyptian queen from the Ptolemaic family, a dynasty installed in Egypt by Ptolemy, a companion of Alexander the Great (356–323 BCE), after the latter's death, was intelligent and educated – and apparently very beautiful. Put another way: her feminine armoury was well-stocked and she knew very well how to use the weapons to her own advantage. She beguiled Caesar, with whom she had a son, Caesarion (b. 47 BCE).

During her stay in Rome she created quite a stir with her demonstration of Hellenistic pomp: she gained the people's admiration but was strictly rejected in senatorial circles. After the death of the dictator she gave her favour and doubtless also her affection to Mark Antony, who was the companion and enemy of Caesar's adoptive son Octavian, the future Emperor Augustus. She had three children with him, the twins Alexander and Cleopatra (b. 40 BCE) and Ptolemy Philadelphus (b. 36 BCE). Only their daughter survived the conflict between Octavian and Mark Antony, the conflict of East and West. Both of the sons were killed, since they could have become a threat to Octavian in his fight for power.

Thus it would surely be unfair to see Cleopatra only as a beguiling mistress, an enemy of

Esquiline Venus, c. 45 CE

Rome, or even just as an impressively lascivious beauty who committed a spectacular suicide by allowing herself to be bitten by a poisonous snake in order to escape captivity by Octavian. The surviving likenesses of the last Egyptian queen in no way accord with our idea, which has of course been influenced not least by the film industry, of a beautiful and seductive woman in the prime of her life. The best-preserved likeness in Berlin depicts Cleopatra with an oval, well-proportioned countenance. Her hair, in which she is wearing the diadem, is bundled together and tied into a knot at the nape of her neck. The pronounced nostrils on her slightly bent nose are characteristic. The mouth has little hooks in the corners pointing upwards and the lips are full, almost pouting. The chin is not very pronounced, but it does bring across something like energy. Overall the nose, mouth, and chin very much shape the face: we see a striking appearance, but not a beauty queen. It would be even more absurd to call the likenesses of Cleopatra found on coins the portrait of a beguilingly beautiful woman. The iconographical elements – diadem, hair-style, large nose, and energetic chin – are all still visible on the coins, but overall the features seem coarser.

The statue of the so-called *Esquiline Venus* on the other hand is not at all stingy with her seductive charms. Iconographic similarities and other arguments such as the *uraeus* as an indication of her pharaonic rank have recently led to the interpretation that this Venus is a copy of the portrait statue of Cleopatra as Isis-Venus which Caesar had had consecrated in the Temple of Venus Genetrix in 45 BCE. This opinion is by no means proved, but the idea is appealing.

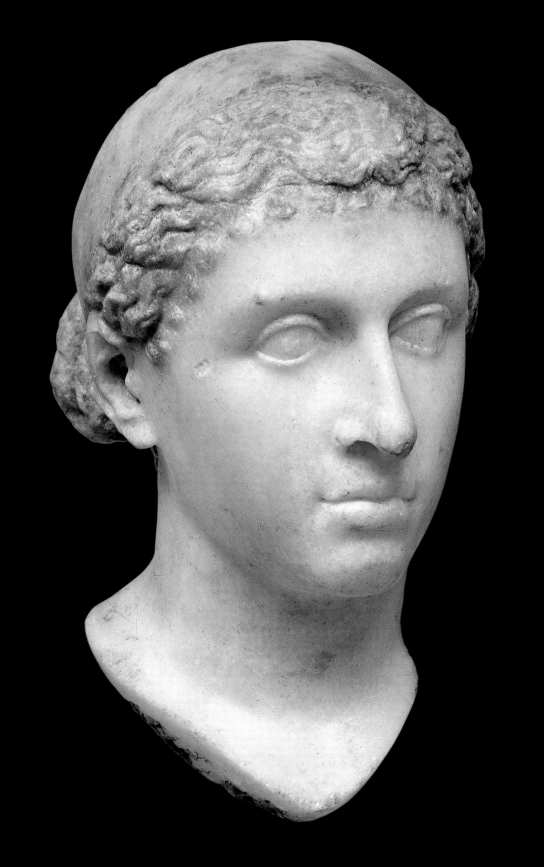

portrait of Gaius Julius caesar

Green slate, marmoreal eye inlays modern, height 41 cm
Berlin, Staatliche Museen zu Berlin – Stiftung Preussischer Kulturbesitz, Antikensammlung

With a few exceptions, all surviving sculptures of Caesar (b.100 BCE) were made after his assassination on the Ides of March (15 March 44 BCE). As a result they reflect the desire of whoever commissioned them – members of the Julian house or partisans – to represent the deified dictator in a timeless-classical manner, in other words in the official imagery of the time. The slight turn of the head is intended to impart to beholders an air of energetic drive, while the eye area with frowning eyebrows was supposed to demonstrate concentration on what was important. Both authority and majesty, *auctoritas* and *maiestas,* can be seen in the eyes. In this likeness the Egyptian sculptor only sparingly reproduced the physiognomic qualities of the man who sealed the fall of the Roman republic with his quest for absolute power. This includes the long, wrinkly neck with a pronounced Adam's apple, the sharp facial features, the intense look, and the extensive baldness.

In light of such features that could almost be called harmonious we can well imagine that a woman like Cleopatra also felt physically attracted to this exceptional politician and military commander – in addition to her politically motivated desire to recruit the master of Rome for her own plans. However, just like Cleopatra's effect on Caesar, the external charms were less important than the entire package of the powerful dictator with his impressive intelligence; but it is well known that power always has an erotic aspect.

A glance at a coin portrait emphasizes Caesar's austere character with his wrinkly long neck and the deep groove between his nose and his lips. A marble portrait from Tusculum even shows the irregular curvature of the skull and the advanced baldness: both are individual features that Caesar could not have been happy about. He may however have consoled himself with Cicero's realization: "solos sapientes esse, si distortissimos sint, formosos – it is only the wise ones, even if they be deformed, who are beautiful" (Cicero, *Pro Murena* 61). In order to consider Caesar as the exceptional phenomenon at the sunset of the Roman republic that he doubtlessly was, and to better understand the upheavals he accelerated or caused, a few noteworthy features should be mentioned. Caesar's name became the title of the future rulers of Rome, the emperors, and passed also into other languages (czar, kaiser). He was the first Roman to be granted by the senate the right to have his own image struck on coins during his lifetime, an unparalleled outrage for a sworn republican that did however soon become a common political practice. Portrait statues of the dictator that individual communities erected in his honour were elevated to the status of divine statues by legal decree *(lex Rufrena)*. And not least, Caesar was the only human and ruler of Rome to have had his own temple erected in the Forum Romanum, where his ashes were also laid to rest. The man who traced his family tree back to the goddess Venus became a state god himself after he was assassinated by Brutus and his fellow conspirators.

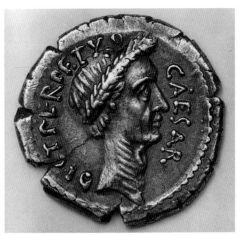

Roman denarius with a portrait of Gaius Julius Caesar, 44 BCE

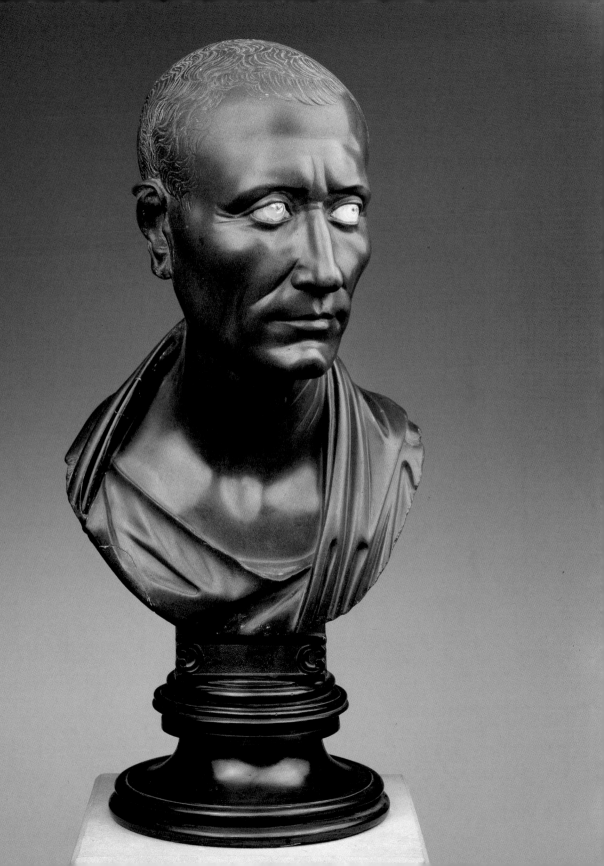

portrait bust of cicero

Marble
Florence, Galleria degli Uffizi

He is one of the most significant people of Antiquity: the lawyer, statesman, orator and philosopher Marcus Tullius Cicero (106–43 BCE). He was a member of the equestrian class, was not originally from Rome, and was a *novus homo,* i.e. the first man in his family to achieve senatorial rank and to hold the office of consul, the highest office in the Roman state. His fate is symptomatic of many a biography during the upheavals of the late republic with its frequently changing friendships and enmities that finally came to an end with Caesar's assassination, the power struggle between Mark Antony and young Octavian, and the beginning of the Roman imperial period. Cicero was no longer alive to witness Octavian's victory or rather the beginning of his principate as Augustus. He was murdered as he was trying to flee, thus he may have been the most famous victim of Mark Antony's vengefulness. This fine portrait shows the exceptionally gifted orator and letter-writer at a mature age with the skin on his face already slackening and his features becoming fatty, with numerous wrinkles around his eyes and a receding hairline that is carefully covered by hair combed over the area. He has the high forehead of a thinker, structured by horizontal wrinkles. The eyes with the frowning eyebrows are staring into the distance with a critical expression, while the slightly opened mouth suggests something akin to contempt. The turn of the head still lets us feel the echo of the energy and charisma that emanated from an extraordinary man with a tendency to be vain.

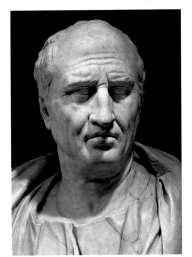

Portrait bust of Cicero,
c. 50–43 BCE

In contrast to Greek art, Roman art was not familiar with portrait statues of contemporary philosophers or famous orators, even though we now would expect such an honour for Cicero. Thus the model must have been an honorary statue of Cicero that was most likely set up for the political gains he created for the state, and not for his literary achievements. The republican Cicero was still canvassed by Caesar, since the dictator valued him as a worthy conversational partner and as a polished orator who had composed important discourses on oratory *(De oratore)* and on the state *(De re publica)*. After Caesar's assassination Cicero supported Octavian, even though he must have suspected that he was in no way interested in a real restoration of the Roman republic. Caesar's murderer, Brutus, criticized him harshly for this. Cicero's rhetorically powerful attacks on Mark Antony, contained in the fourteen so-called Philippics, were the final straw. Octavian removed his protective hand from him, the price for an alliance with the (still) powerful Antony. Thus Cicero's name was one of the first on the list of those proscribed, a list containing the names of everyone who was considered to be an enemy of the state. Those who had remained faithful to him did try to get him aboard a ship bound for Greece in the darkness of night, but Mark Antony's hit-men captured the group. Recognizing the hopelessness of his situation, Cicero is said to have stuck his head out of the litter in defiance of death. Mark Antony had Cicero's severed head and the right hand with which he had written the Philippics nailed to the rostrum in the Forum Romanum, so great was his hatred for the man who was better able to fight and wound with words than he ever could have done with a sword.

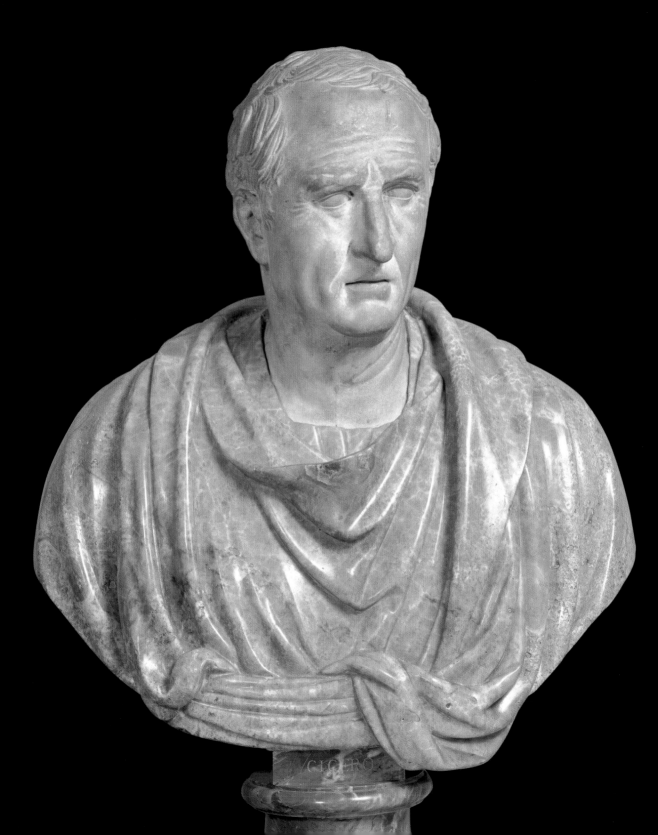

ıdeal landscapes

Painted wall stucco
New York, The Metropolitan Museum of Art

A wall in cubiculum M, a bedroom in the famous Villa Boscoreale on the southern slope of Mount Vesuvius, literally provides a deep look into the development of painting of the so-called second style. The complex's owner, a certain P. Fannius Synistor, evidently had sufficient financial means to afford the stunningly elaborate and expensive painting of the walls in this room. Their illusionistic vistas of ideal landscapes with temples, grottos, benches and other features, as well as natural prospects with plants and all kinds of animals, are impressively well developed here. While the side walls of this bedroom are decorated with complex architectural features, views of small temples, and outlooks on to buildings rising up behind each other, the dominant view on the back wall is that of a park-like landscape. Between and next to entablatures supported by pilasters with Corinthian capitals we look out onto an idyllic and diverse garden complex. In the foreground of a grotto is a fountain whose two water basins are being fed from the rock wall; a small gold-coloured statuette is in the background, maybe an indication of the sacred nature of the spring. Ivy tendrils are growing above the opening of the grotto, which is inhabited by several birds. Above it a terrace, covered by a pergola with vines, rises in front of a blue sky. It almost seems as if we could hear the birds singing and feel the landscape's fragrant, warm air.

To the left of the red column surrounded by filigree bronze tendrils, the wall of Cubiculum M presents, as if on a window sill, a glass bowl filled with fruit, and below it a landscape with houses and temples is painted in ochre-coloured pastels. The latter representation is an example of monochrome painting that was a popular contrast to the colourful motifs on the walls. The buildings in the town rising from a slope above a river are outlined with just a few, but clear brush strokes. A bridge filled with many people crosses the river in the foreground. Boats are drifting by. Such picture motifs from the genre of landscape painting had their models in the Hellenistic art of Greece. It was during this period that they made their first appearance on Roman frescoes. It is easy to imagine how a large garden complex could have followed behind the terrace, with fountains and other things capable of making life pleasant. In the midst of such complexes there were always copies or reproductions of some famous artwork dating from the Greek classical period, which would delight aficionados and initiate many an educated discussion. Such ensembles could be made up of complete statues or groups, but also of herma galleries with the portraits of famous poets and philosophers, such as Homer, Plato, and Aristotle, or with the heads from famous artworks, such as Polykleitos' *Doryphoros.*

Illusionist wall decoration from Villa Boscoreale,
2nd half of the 1st century BCE

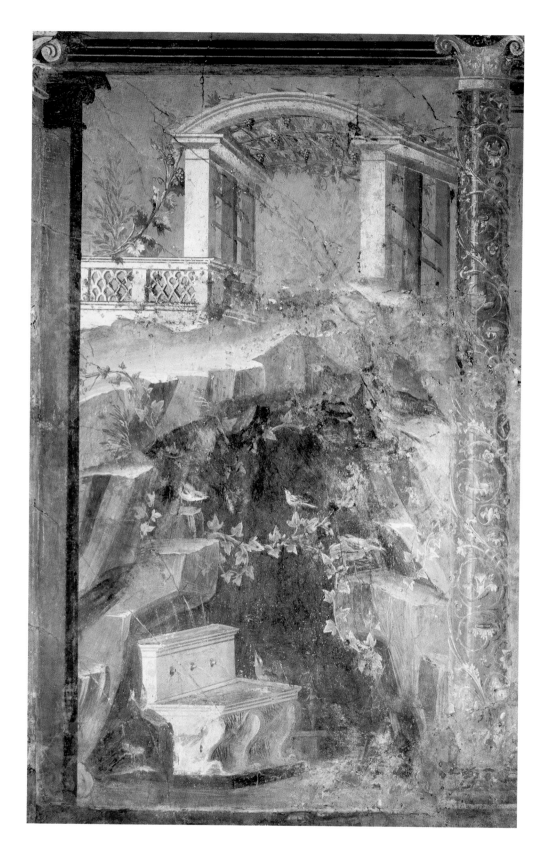

garden landscape

Wall painting, length 11.70 m, height 2.72 m
Rome, Museo Nazionale Romano (Baths of Diocletian site)

In such a cool and flowering ambience, guests could forget the shimmering summer heat. Anyone invited to this underground room, which was insulated against damp, to eat or just to relax, was a guest in an imperial house, more specifically: in the house of Livia, the wife of Augustus. She owned a villa near Prima Porta outside the gates of Rome in the hilly landscape close to the northbound Via Flaminia. It was at this villa that the famous statue of *Augustus of Prima Porta* (ill. p. 49) was found. Livia evidently wished to have a portrait statue of Augustus close by after her husband died; the marble copy with the image programme that shows the return of the Roman military standards by the Parthians in 20 BCE allows us to conclude she decided on one of the most significant bronze sculptures of Rome's public space.

It must have been an impressive experience to eat in this underground room in her villa with its longitudinally constructed barrel-vault ceiling as if under a cave roof whose edge rose into the blue sky on the horizon. In front of them, visitors saw a cultivated and densely vegetated park landscape, whose end can be imagined somewhere in the impenetrable green. In order to transfer this imaginary garden into external space even further away from the onlooker, a path winds around it, bordered by a double fence made of bronze railings and a perforated marble balustrade. There is a conifer in each of the indentations. Beside them are pomegranate or quince trees full of fruit.

Further trees to have been identified are spruces, laurels, pines, cypresses, box, and oleander. Among the other plants identified are roses, chrysanthemums, and lavender-coloured poppy. Thirty bird species can be found on the branches, on the balustrade, or flying through the air.

From an art-historical aspect the painting in the Villa of Livia still shows the illusion woken in onlookers of a deserted landscape created by the realistic representation or reproductions of plants and animals that is characteristic of the so-called second style. However, at the same time, with the silhouette-like contours standing out sharp against the green background, or the fine grid pattern of the bronze fence in the foreground, it already points to a further development in mural painting. In the midst of this flora and fauna, imaginary, yet copied from nature, whoever lay down to eat on a *lectus triclinaris* in this underground room surrounded by all the beauty of this painted perfect landscape, could truly forget the outside world with its problems and ugliness. Perhaps guests daydreamed about smelling the flowers and hearing the birds sing – the idyll that surrounded them definitely did not stand in the way of such a suggestion.

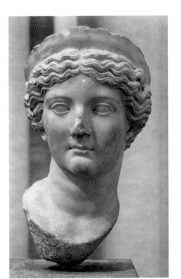

Portrait of Livia, c. 20 CE

"ʜow dewy, how exceptionally fresh the grass and trees and flowers, how plump and shiny the fruit! ᴘomegranates, like ʀenoir painted them. ʙird song enchants the ears. ᴛhe distance remains magically impenetrable."
Bernard Berenson, 1950

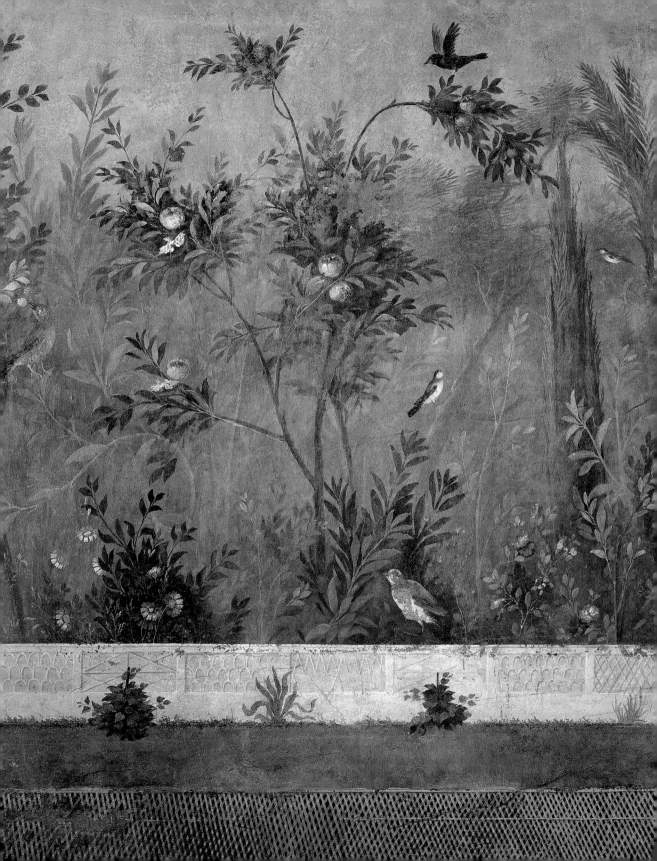

Portrait head of Augustus from Meroe

Bronze, height 44 cm
London, The British Museum

It is the eyes that fascinate the onlooker, because usually the eyes of bronze statues made of other materials have been lost. The eyeballs are made of white marble, while the iris is made of a green glass paste and the pupil of a dark glass paste. The eyelashes have broken off, which is the reason why the eyes seem to be pulled wide open.

The portrait of Augustus was discovered in Meroe in 1910, the ancient capital of the Ethiopians. It was buried under the threshold of a building that was presumably built on the occasion of a victorious military campaign against Roman Egypt. Evidently the head and the lost body – it may have shown the emperor wearing a toga or in his metal armour – were part of the booty. The likeness embodies the so-called "Prima Porta" style, whose original was probably created around 27 BCE when Octavian was honoured with the sobriquet "Augustus" after he had relinquished all extraordinary powers. Of the more than 250 surviving likenesses of the Princeps, around 170 are in this "Prima Porta" style. In his *Res Gestae,* the account of his deeds, he reported: "From then on I exceeded nobody in influence anymore, but everyone in standing." (*Monumentum Ancyranum* 34). Nonetheless he naturally continued to be in political and military control of Rome and the empire. Augustus and his political advisers created a ruler likeness with this image style that would remain valid for around a century.

It is easy to see from which pool of art language the vocabulary for the Augustus portrait was taken: it was classical Greece. It is no coincidence that the head's conception, with its carefully arranged hairstyle

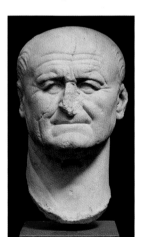

Portrait of Emperor Vespasian, between 69 and 79 CE

and the typical distinctive feature of the tong-shaped curly fringe, recalls the ideal statue heads by the Greek sculptor Polykleitos. One such statue is the so-called *Doryphoros,* the spear bearer, already considered in ancient literature to be a classical representation of the human body. Thus Augustus distanced himself from his earlier portraits, which were still indebted to the ideal of the Hellenistic rulers and showed an energetic, confident military commander who considered himself a successor of Alexander the Great. Augustus and his circle managed to express Roman values in picture form by making use of a classical period considered exemplary and unsurpassed. Augustus was surrounded by an untouchable authority, *auctoritas.* He radiated *gravitas,* dignity, while *sanctitas,* religious consecration, was also a factor, when for example Augustus was shown wearing a toga covering his head, making a sacrifice.

After the design for the official portrait had been approved, the model was quickly distributed throughout the four corners of the empire; after all the Princeps had to be omnipresent in the empire through his likeness. Whether and how the emperor posed for the design or what sketches and preliminary works were used, remains uncertain. In any case it can be assumed that several copies of the original were produced in sculptors' workshops in the city of Rome that were working by order of the emperor. They then subsequently supplied other workshops with these sculptures. Another significant medium for fast distribution will have been the plaster mould of an original, which was easy to transport. The head from Meroe shows us how fast the "Prima Porta" type as well as later official emperor likenesses reached the furthest reaches of the Roman Empire. It could not have been created later than around 25–20 BCE, since it was during these years that the Ethiopians went on their military campaign.

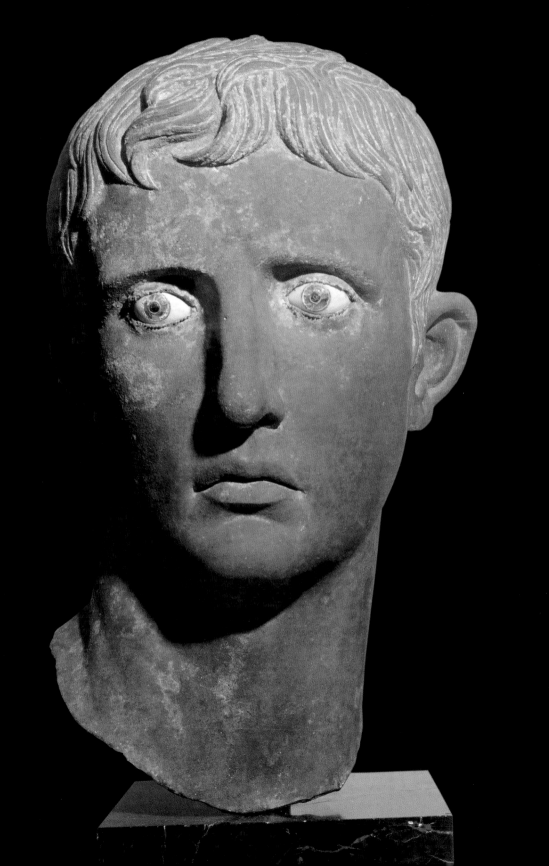

apollo with a kithara

Fresco fragment, height 56 cm, length 69 cm
Rome, Antiquario Palatino

This fresco fragment provides a look into Augustus' private chambers which the Princeps had had constructed for himself on the Palatine, and a look at their pictorial decoration. Originally this scene formed the centre of a frieze, as is confirmed by the interlaces colliding at the top. The young man resting on a marble throne, holding a musical instrument can easily be identified as one of Augustus' patron gods: it is Apollo. The naked body is covered only by an purple-dyed cloak wrapped around his lap. The god is wearing a laurel wreath in his long hair. He is looking at the kithara which he is holding on his knee with his left arm as if he had just stopped singing and was listening to the last note fade away. The bright-blue background forms an aura that positively stylizes the likeness of Apollo with his soft-smooth skin tone into an exaltedly detached apparition. A scale of calm and delicate colours has a general dominance against of the blue background: the grey of the marble throne, the lustre of the mother-of-pearl on the pearl strings entwining the *omphalos* (navel of the world) below the throne, the iridescent red, purple and pink of the gown, as well as the radiant bronze colour of the kithara with its ribbons.

This god of Augustus has nothing to do any more with the Apollo of young Octavian, except for his name. In the previous years the Princeps had indeed publicized a new image of the god in whose vicinity he had had his house built on the Palatine, namely close to the Temple of Apollo Palatinus. The civil war following Caesar's assassination should be forgotten: the successful avenging by Octavian and his patron Apollo of the hubris of his opponent, the Dionysus-adherent Mark Antony, that had led to the victory of Octavian's fleet at Actium in 31 BCE. A beautiful, gentle Apollo had taken the place of the belligerent god of earlier days, who – as the *omphalos* below the throne shows – with his orderly and lawgiving power became a guarantor of the happy new time that had appeared with Augustus' reign. This was also the image the Princeps wanted to see in his private rooms and it was also the way his visitors were supposed to experience him: classically exalted, lordly, and calm. Just as Augustan classicism is palpable in this painting and in the marble cult-image triad in the Temple of Apollo Palatinus, the terra cotta reliefs in a temple building with scenes from the Apollonian body of legends also embody this new spirit. Here the ancient Italian material, clay, signals the fostering of ancient Roman-Italian tradition by Augustus, while the scene depicting the argument between Apollo and Hercules about the tripod is part of the already valid and soon dominant imagery of Greek art that was considered exemplary. Decorative clay plaques were only used for a short while after this. They had to make way for the more durable and more popular marble.

Apollo and Hercules argue about the tripod, end of the 1st century BCE

"Jupiter is my father; what is and what was and what will be,/ I will reveal it; that lyre and song harmonize with each other, that is my work."

Ovid, Metamorphoses, I, 517f.

Augustus of Prima Porta

Marble, height 204 cm
Rome, Musei Vaticani

There is no doubt that this representation of Augustus, discovered in 1863, is one of the most famous artworks of Roman Antiquity. It is not just the statue's excellent state of conservation, but also the rich, textured relief embellishment on the ruler's metal armour as well as the location in which it was found all make this marble likeness one of those strokes of luck to which we owe profound information about the nature and self-conception of Roman state art.

The over-life-sized likeness once stood on a garden terrace in the Villa "ad gallinas" north of Rome overlooking the Tiber, which belonged to the Princeps' wife Livia. Thus it is safe to assume that the statue reflects political views held by the imperial family.

Today scholars assume the marble statue to be a copy of a lost original made of bronze, perhaps even gilded or silver, once located in a central site in Rome.

Augustus is depicted as Imperator in his military cloak. He may have held a laurel branch – the symbol of a victor – in his outstretched right hand. A lance probably rested in his left arm. In the centre of the armour we can see the return of the Roman military standards lost by Crassus during his campaign against the Parthians in the east. King Phraates IV is shown handing over the legion's eagle and the standard. This event, dating back to 20 BCE, is however only the outward motive for a more comprehensive, programmatic statement of Augustan portrait art, which also made its mark in the literature of the time, particularly in the *carmen saeculare,* which Horace had composed in 17 BCE for the festival in honour of Apollo and his sister Diana, the official beginning of a peaceful and golden age. The mourning female figures sitting to the left and right evidently represent subdued peoples. The dragon trumpet and wild-boar standards most likely represent the Celtic peoples in the west. The figure on the left probably personifies the humbled peoples of the east or Germania, who were obliged to pay tribute, but were not disarmed. Below it are the patron deities of Augustus, Apollo on the griffin and his sister Diana shown riding on a doe. Apollo appears here as a god of light, guaranteeing the new golden age that had been prophesied by an

oracle. Diana is shown as a symbol of night, holding a torch. The fruits of this much blessed age are shown by the earth goddess Tellus down below with her cornucopia. She is crowned with ears of corn and two children are playing by her side. The tympanum at her feet also characterizes her as Magna Mater, as the mother goddess of Asia Minor, who in turn relates to the Trojan ancestry of the Romans and the imperial Julian family. At the top, Caelus, the sky, spreads out his cloak, while the sun god Sol is rising into the wonderful morning of the new age in his quadriga; the moon goddess Luna opposite him is being carried by Aurora, the giver of morning dew. Thus this picture programme with its classical Greek elements demonstrates that Augustus' reign was the divine will, whose victory over the Parthians was merely a further historical achievement of his government, which was such a blessing for the people and the Roman Empire.

"BUT I have observed that you do not just worry about the daily lives of the people and about the condition of the state, but also about the construction of proper public buildings, so that the EMPIRE is not just increased by the addition of new provinces, but also that it expresses its majesty in the great grandeur of its public buildings."

Vitruvius, Address to Emperor Augustus in: On Architecture

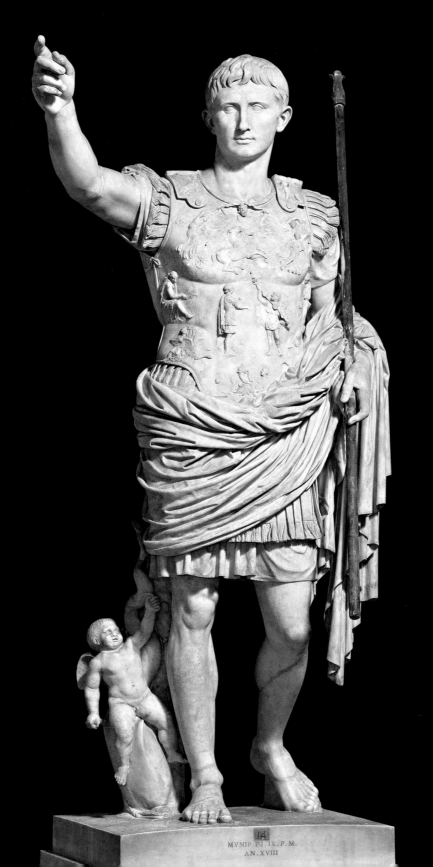

wall of cubiculum в in the villa Farnesina

Fresco painting on stucco
Rome, Museo Nazionale Romano (Baths of Diocletian site)

The paintings and stucco works, discovered on the walls of a stately villa dating from 1506 in the grounds of the Villa Farnesina during the regulation of the Tiber in 1878/79 are without a doubt some of the highest-quality examples of Roman ornamental art. The frescos of the uncovered rooms as well as the stucco decorations of the ceilings were removed and the remaining walls were filled in again. The site of their discovery, Rome, as well as the scale of the estate, the quality of the interior, and their dating to the early reign of Augustus, finally led to the conclusion that this must have been the property of one of Rome's great men or even of a leading member of the imperial family. It was thought it may have belonged to the military commander Agrippa (64–12 BCE), the long-time friend and son-in-law of the emperor, who had married Augustus' daughter Julia in 21 BCE. Enticing as this supposition is, there is no clear evidence for it. However, the villa surely belonged to a man who did not play an insignificant role in ancient Rome, either in the imperial household or in senatorial circles.

Caryatid, c. 20 BCE, fresco

The wall shown here is divided into a flat pedestal area as well as a main and upper area. The glimpses into garden landscapes which we saw in the fresco at the Villa Boscoreale have disappeared to make for a two-dimensionality whose architectural elements basically no longer have any regular functions. Instead, the wall is decorated with ornaments, pictures, and female figures, who are either holding framed monochrome pictures or are placed in an imaginative, architectural context at the top of the fresco. The architecture with its unreal character can only be interpreted as a game here. In the centre, two columns on a protruding pedestal frame an aedicule with tendrils on the top of the pediment. In between there is an area that does recall a trompe l'oeil, but is probably better interpreted as a straight painting. It shows Dionysus as a boy, being taken care of by the nymph Ino-Leucothea. She has the god sitting on her lap and is placing ivy on his head. Two women in the background are watching them. The scene is set in a rural temple, marked by a wall, gate, tree, and several effigies of gods. Next to the main picture, winged creatures are carrying two white-ground pictures in elaborately designed frames. A woman with a harp is sitting on the left, another woman is bringing her a rabbit held in a bunched-up part of her garment. On the right there is a complementary opposite, with a woman sitting, holding a lyre, who is being given a myrtle branch by a second woman. While the large picture has us recognize a genre scene in the Hellenistic style, the two pictures being held up by winged figures are reminiscent of the Attic *lekythoi,* pictures painted on a white ground, which were customary grave goods in the classical period. Pictures in this style and with comparable subjects are also known on marble panels from Rome, Pompeii, and Herculaneum. A number of these pictures, particularly the large ones, were probably copies of famous paintings from classical and Hellenistic times, or Augustan modifications of famous models that have not survived. The wall in the Villa Farnesina thus also gives an idea of the storage and presentation of painting collections in Roman stately homes. Whoever could afford it had originals in their house, others made do with paintings integrated in the wall decorations, although there was a popular opinion during those years that artworks in the possession of the rich should be handed over to the public. Thus many a person of standing must have satisfied himself with the painted copies of the originals he had given to the people, so that he would not be publicly criticized.

Ara Pacis Augustae

Marble, size of the sacred area 11.60 m x 10.60 m, ground area of the altar 6 m x 7 m
Rome, Lungotevere in Augusta

In his publicly posted account of his deeds, Augustus explains that after his victorious return from the provinces of Spain and Gaul the senate decided "to consecrate as thanks for my return an altar of Augustan peace on the Field of Mars where officials, priests, and Vestal Virgins make a sacrifice every year at the behest of the senate" (aram Pacis Augustae senatus pro reditu meo consacrandam censuit ad campum Martium, in qua magistratus et sacerdotes virginesque Vestales anniversarium sacrificium facere iussit; *Monumentum Ancyranum* 12). This altar, pledged in 13 BCE and consecrated in 9 BCE – it was found during excavations and largely reconstructed – can be considered a hymn to the Princeps and his family, to Rome's history and the "golden age" that came with the *Pax Augusta,* the Augustan peace translated into a pictorial medium full of ingenious iconography of myth and reality.

The actual sacrificial altar is located in the interior of a complex surrounded by a wall that is accessible from two sides. The two long sides are divided horizontally by meander patterns. At the bottom a filigree plant and tendril ornament are displayed. At the top a procession made up of members of the imperial family and state dignitaries is represented. Augustus with his covered head stands in the middle of the events as the *pontifex maximus,* the chief priest, staking out the area of the altar to peace. He is accompanied by other priests and family members whose procession could almost be called a dynastic succession concept. The short sides have depictions of Aeneas making sacrifices. They remind beholders of the ancestry of the Julian imperial family as descendants of this Trojan hero. A depiction of Mars with the she-wolf and Romulus and Remus reminds beholders of the progenitor of the Roman people – *pater Mars.*

The other side depicts the goddess Roma and the famous representation of Tellus/Pax, the peace-giving earth mother. She is holding playing children in her arms, fruit is lying in her lap, and an ox and a sheep are peacefully resting on the ground. Air and water are depicted allegorically; in fact the entire Tellus relief is an allegory to the peace guaranteed by Augustus, which provided growth and prosperity, peaceful co-existence and happiness to the people – all statements which every beholder of the time would have understood immediately and which he would have known well from the works of the court poets such as Horace and Virgil. The calm and majesty of the protagonists and the mythical representation, no less than the filigree ornamentation, are translated by stylistic instruments from classical Greek art. It is no accident that the composition of the processional frieze with its flat perspective recalls the Parthenon frieze in Athens, the classical example par excellence. However, the artists, who may well have been Greek, have used Greek motifs to express genuinely Roman statements and views on the *Ara Pacis.*

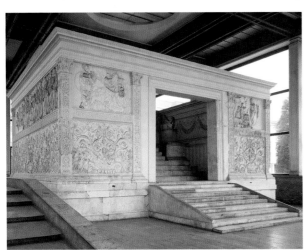

Ara Pacis, 9 BCE, full view

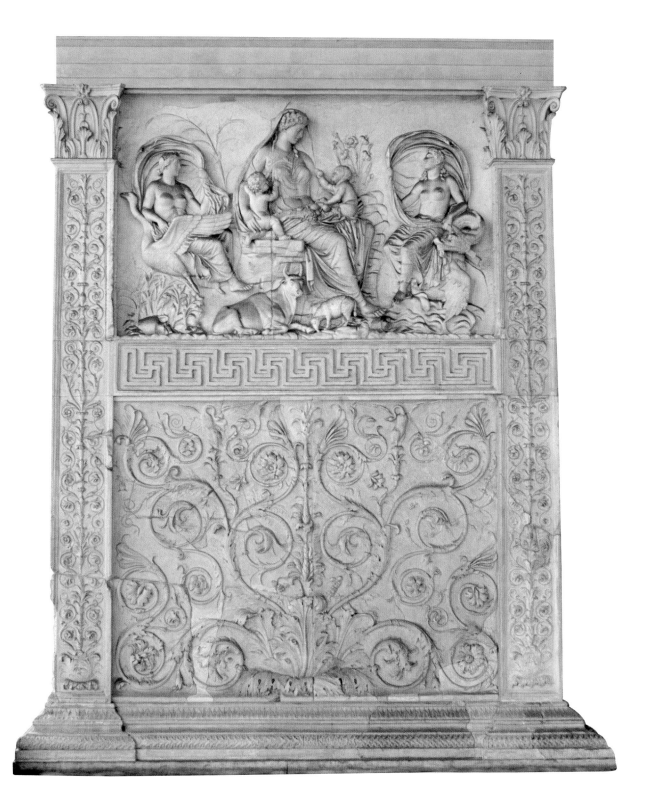

mars ultor

Colossal statue, copy from the time of Domitian, marble, height 3.60 m
Rome, Musei Capitolini

Mars Ultor, the divine "avenger" bringing the murderers of his adoptive father Caesar to justice, was the most important deity for Augustus alongside Apollo. Young Octavian had already pledged to build the vengeful god of war a temple in 42 BCE, but he was only able to consecrate it in 2 BCE; Apollo was able to move into his house on the Palatine earlier. In the cult image group in the temple in the Forum Augustum it was not a young, athletic, ferocious-aggressive god of war who stood between the progenitor of the Julian house, Venus Genetrix, and *divus Iulius,* deified Caesar, but an old bearded one. This picture of a *pater Mars,* the fatherly god, fitted better into the new age after the blood-letting of the civil wars and followed the new policies of the peace-bringer Augustus. The statue was a new Roman creation, in contrast to the cult image triad of Apollo-Diana-Leto on the Palatine, which had been compiled from original Greek statues. Mars is wearing a richly ornamented metal breastplate depicting two griffins next to a candelabrum in its centre; above them is a Gorgoneion. His head is covered by a helmet whose tip is crowned by a sphinx, flanked by two Pegasoi. Mars is leaning on a lance with his right arm, while his left hand is resting on a round shield.

The imagery, such as the standing motif and the Corinthian helmet shape, is clearly Greek, whereas the picture concept is Roman-Augustan; the copy displayed here dating from the time of Domitian still makes use of this concept.

Roman understanding also had an effect on the composition of the cult image group, which had nothing in common with the well-known Greek groups of Mars and Venus. Octavian had already called on Mars as an avenger at the Battle of Philippi and in 20 BCE Augustus could celebrate a second great success that he connected to *Mars Ultor:* the return of the military standards of the Roman legions that Crassus and Mark Antony had lost to the Parthians. If we consider that a legion that had lost its eagle was no longer deployed, i.e. no longer existed, we can understand how significant it was for the Romans' self-esteem to get these military standards back by diplomatic means, an achievement that was sold to them as a "recapture". The significance of the *pater Mars* in the Augustan ideology also emphasizes the fact that Augustus gave the cult of *Mars Ultor* religious privileges that had previously been reserved for *Iupiter Capitolinus,* the old father of the gods. Maybe the father of the city founder Romulus was also supposed to take over from the Jupiter of the republic as the father of the Roman people. The fact that this plan did not enjoy permanent success is shown by the history of the Principate after the demise of the Julio-Claudian dynasty on Nero's death.

"A further surprise for Pierre was the Forum, which stretched from the Capitoline to the foot of the Palatine: a narrow plaza edged in between the neighbouring hills, a depression in which a shortage of space forced the growing city of Rome to place the buildings very close next to each other. It had been necessary to dig down 15 metres to find the venerable ground of the republic under all the soil sediment that had accumulated over the centuries."

Émile Zola, Rome, 1896

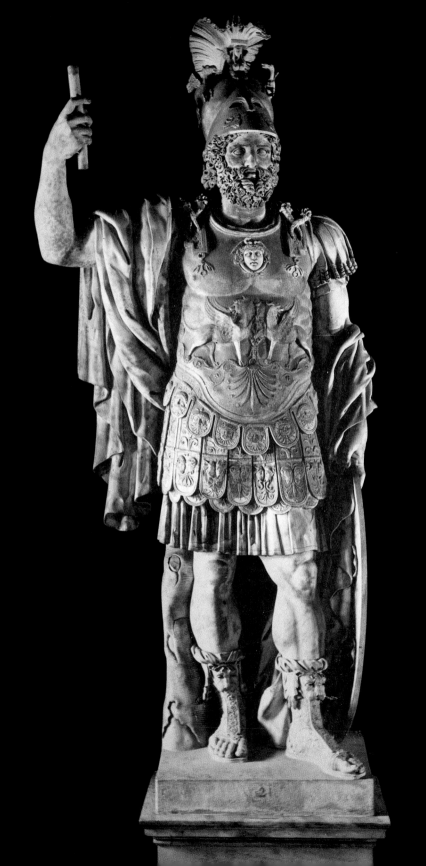

caryatids and нead of ammon from the forum augustum

Marble, caryatids from the Forum of Augustus equal in size to the korai of the Erechtheion
in Athens, height approx. 2.30 m
Rome, Antiquario dei Cavalieri di Rodi

The model character of classical Greek art for the development of the young Principate's official imagery becomes clear again in the pictorial ornamentation of the Forum Augustum. Here excavators found fragments of equally sized copies of the korai of the Erechtheion on the Acropolis in Athens, a rare stroke of fortune, since in this case both the original and a copy of an artwork have survived. Originally the more than fifty copies were arranged in the fascia zone of the lateral halls like their classical models in an architectural context; in the gaps were round shields with different heads, for example the head of Zeus Ammon. In addition we discover something about the appearance of the korai from the Erechtheion, whose arms have not survived. On the evidence of the fragments from the Forum of Augustus they wore snake-like spiral bracelets and held in their hands donation bowls whose bases were decorated with acorns.

The forum is one of the most significant building projects Augustus undertook in Rome. With its picture programme, the forum really takes on a key function for the understanding of the Principate ideology and the state art. In 42 BCE, before the Battle of Philippi in

Greece against the murderers of his adoptive father Caesar, Octavian is said to have vowed to build a temple for *Mars Ultor,* the vengeful god of war. It took forty years for Augustus to fulfil this promise, then he consecrated the temple together with the connecting Forum Augustum. The surrounding walls, sometimes over 30 metres high, served as a boundary between the complex and the neighbouring residential areas as well as a protection against fire. On either side of the Temple of Mars Ultor, which in contrast to Greek temples stood on a pedestal and had its back wall joined to the surrounding wall, were two halls of columns with two exedras. There Augustus had statues erected of gods, mythological heroes, and historical personages who were all somehow connected to the rise of Rome and that of his own family.

In the left exedra, viewers could see Aeneas fleeing from burning Troy, carrying his father on his shoulders and holding the hand of his son Julus-Ascanius. Next to them are members of the Julian family who after all traced their family tree back to Aeneas and thus to Venus. Romulus raising a lance stood in the other exedra. He, the son of Mars and founder of Rome, was surrounded by *summi viri,* famous Romans to whom Rome owed its rise. The statue plinths recorded their names and offices as well as their military deeds and civic accomplishments. In the square in front of the temple is a statue of Augustus in a quadriga. Augustus also had been conferred the honorary title *pater patriae,* "father of the fatherland". The fate of Rome had fallen into Augustus' hands, just as Virgil had predicted in his *Aeneid*. Thus the circle of events closed for every visitor who was fortunate enough to experience a new time of peace and a new golden age under the reign of Augustus after decades of civil war, just as Virgil and Horace proclaimed.

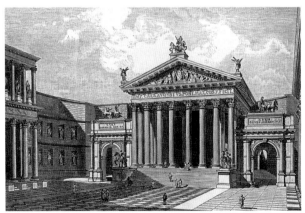

Forum Augustum, Mars Ultor Temple, Rome, c. 1890, wood engraving

Augustus as the ruler of the world

Sardonyx, cut from a pale layer in cameo technique, height 19 cm, width 23 cm
Vienna, Kunsthistorisches Museum

The representations on the monumental state reliefs all glorified the emperor's deeds and virtues – see for example the *Ara Pacis Augustae* or the Arch of Constantine – in a special way, but there was another picture world beyond it that formulated the state of affairs from the perspective of the court in an idealizing but at the same time very subtle manner. It is the world of carved semi-precious gems, in which the images were either cut in a raised relief (cameo) or in a negative relief (intaglio). These valuables were presents or accolades for the imperial family and selected dignitaries. Of course the picture programme on the cameos and the intaglios corresponded to that propagandized on the state reliefs, such as the demonstration of excellence *(virtus)*, piety *(pietas)*, clemency *(clementia)*, dignity *(maiestas)*, or justice *(iustitia)*.

However, the statement about the emperor's god-willed rule of the world and his unattainable, almost god-like dignity could also be manifested quite clearly in a picture and be projected on a panegyrical level through highly intellectual innuendo and insinuations from mythology or the world of the gods. Thus it was not something for the "simple" populace.

This fine *Gemma Augustea* is one of the grandiose examples of such courtly art. The item probably even belonged to the imperial family's treasure. The subject is the dominance Augustus achieved through military victories. The Princeps is sitting in a throne beside the helmed city goddess Roma. Between them we can see the emperor's auspicious star sign, the

Cameo with the Three Graces, 1st century CE

capricornus (Capricorn), an astral emblem hinting at his predestination to be the saviour of mankind. The eagle at his feet, the heroic nudity, and the sceptre in his hands all associate Augustus with the highest god Jupiter; here it remains open whether the emperor has a comparable position on Earth to Jupiter's in heaven, or whether he is even being identified with him. Beside the throne is the Earth goddess Tellus with two boys – a configuration we already know from the *Ara Pacis* – as well as Chronos, the god of eternity. These are all symbols of the emperor's eternal reign in this world. The oak wreath for the salvation of humanity from the upheavals of the civil war is being held by Oikoumene, the representative of the inhabited world. Tiberius, the triumphant military commander and Augustus's successor, is climbing out of the two-horse chariot being steered by Victory on the opposite side of the picture. The young man is probably prince Germanicus, a further claimant to the throne in the dynastic line. The lower scene shows soldiers and two naked heroes setting up a victory monument with captured weapons: a *tropaeum*. A pair of captured barbarians are sitting in front of it. The woman with the two spears and the man with the hat dragging the barbarians, who are begging for mercy, by the hair are presumably representatives of the world of the gods, maybe Diana and Mercury. The enemies are probably members of the equestrian peoples that Tiberius had conquered during his military campaigns in Pannonia. The dynastic aspect in this picture is more than clear and Augustus's desired succession arrangement is furthermore exaggerated to a cosmic level and translated into an allegorical imagery certainly above the heads of simple rustics, but all the more understood by members of the imperial court.

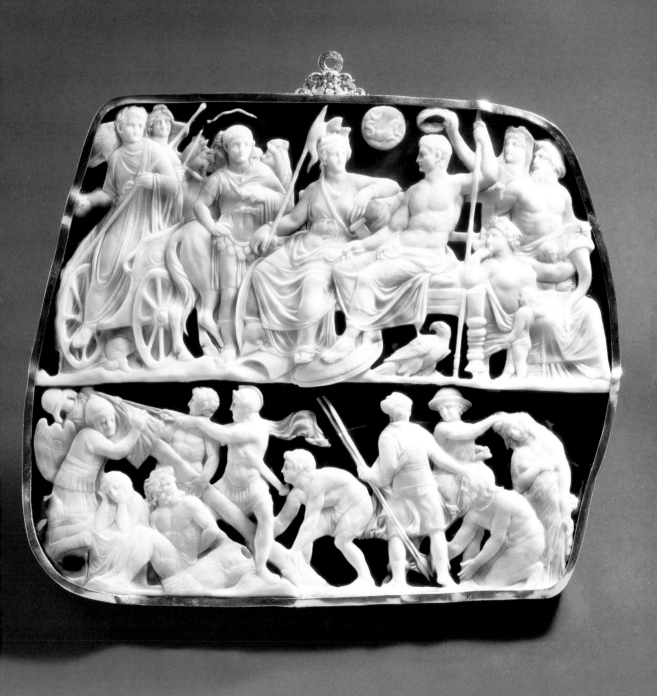

Barberini Togatus

Marble, height 165 cm (not including the head)
Rome, Musei Capitolini

The likeness of a Roman presented here is less remarkable for its artistic quality than for its attributes. Clad in the wide and carefully arranged toga, which was once again elevated to the position of state uniform under Augustus, and wearing the typical footwear, the *calcei,* the man is shown to be of senatorial rank. He is carrying two busts in his hands showing men of different ages. The more portly of the two heads in his left hand is probably the older of the two. These busts are *imagines,* likenesses of his own ancestors. In this case they are probably the man's father and the grandfather. This custom was a singularly Roman one and one which played an important role for the creation of the Roman portrait; similar representations were unknown in Greece, the great model for Roman artistic language. This *ius imaginis,* the right to present likenesses of one's own ancestors during a relative's funeral procession was only permitted to members of the aristocracy and those families who already had a senator within their ranks.

The Greek historian Polybius (c. 200–120 BCE) described this form of funerary celebration in detail. A portrait mask was made of the deceased family members, which were kept in a shrine in the atrium of their home after the burial and were presented to the guests of the master of the house at appropriate occasions. It seems strange to us today that on the death of a family member, people

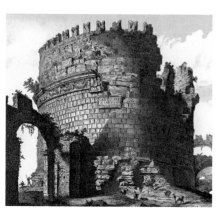
Grave monument of Caecilia Metella on the Via Appia Antica, about 1880, lithograph

would put on ancestor masks resembling the deceased in build and also put on the clothes of the former office holder, in other words the toga with a purple hem for consuls and praetors, an exclusively purple toga for those who had been censors, or the gold-embroidered toga for those who had been able to celebrate a triumph during their lifetime.

The masks and clothes could also be put on wax dolls instead of on selected people. All the office's insignia, i.e. also the *fasces* carried by the lictors as a sign of their right to order the flogging or execute a Roman citizen, were carried ahead of the masks. The more prominent the family, the more ancestor masks could be seen during the *pompa funebris,* the funerary procession, and the more magnificent was the presentation of the family history. The wearers of the masks sat down on ivory stools in front of the *rostra,* the orator's platform in the forum. After the deceased's son had finished his funeral eulogy, he would have stepped in front of these chairs and spoken about the fame and the deeds of each of the ancestors. The effect of this display of celebrity will not have gone unnoticed by the younger citizens, since these dead men were immortal in their fame through the praising of their lives, and this was a quite significant motivator for their own ambitions and desires. Of course this kind of self-representation and the associated elitism had its critics. A *novus homo,* a social climber such as Marius, Sulla's opponent, fulminated that he could neither boast *imagines,* nor triumphs nor consuls amongst his ancestors, but he could boast military standards and distinctions, as well as scars on his chest. "Those are my *imagines,* that is the nobility, not gained by inheritance as others have, but earned through my own plentiful labours and dangers." (Sallust, "Bellum Iugurthinum" 85, 30, 1st century BCE) Thus the *Barberini Togatus* cannot have been the *novus homo* he was always said to be. Since he is carrying likenesses of his ancestors who must have held senatorial offices, the unknown man already belonged to the aristocratic establishment.

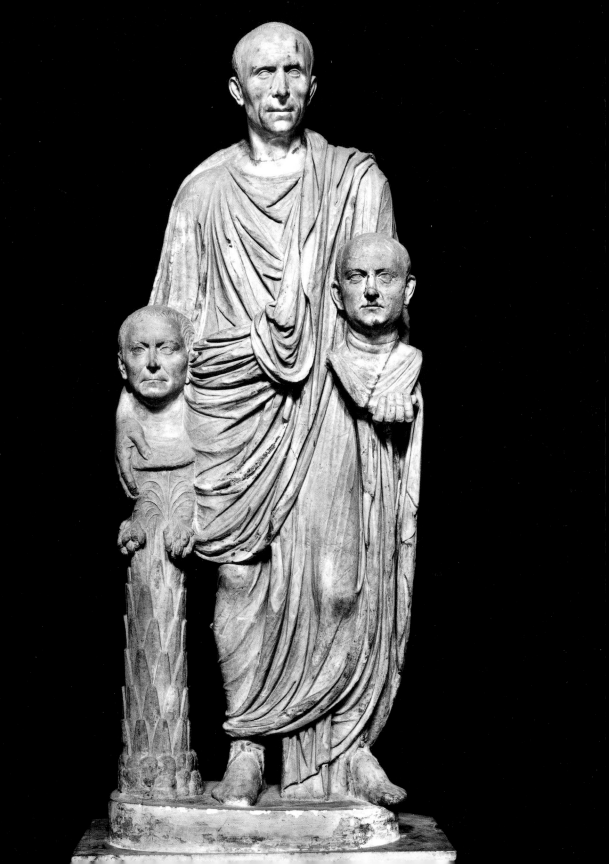

grave relief of Aiedius

Marble, height 64 cm, width 99 cm
Berlin, Staatliche Museen zu Berlin – Stiftung Preussischer Kulturbesitz, Antikensammlung

The man and the woman look at the beholder as if out of a window and this impression is not that incorrect at all. Such reliefs were embedded into the walls of grave buildings, and/or next to or above the doors leading into the interior of the complex. Whoever left Rome or another larger city via one of the famous roads will have travelled past countless large and small, magnificently and simply designed mausoleums in which deceased families found their last resting place according to their financial means. The grave relief of Publius Aiedius and his wife Publia Aiedia will also have been part of such a mausoleum, in this case of one located on the Via Appia.

Publius was known by the name of Amphio, as can be read. The L means Libertus and thus points to the man's social standing: he was a freedman, an ex-slave. Together with his freedom Publius Aiedius had also received the right to marry. Any children of this union were free from birth. The parents on the other hand were still denied holding most of the public offices. In addition the *libertini* continued to be dependent on their patron. They had to be obedient, show him deference, and naturally vote for him in any election in which he was a candidate.

The imagery language of such grave reliefs of freedmen and women is full of references to their newly acquired status, their social standing and their attempted integration into an imaginary tradition. Publius Aiedius is dressed in a toga as a symbol of his status of *civis Romanus,* of Roman citizen, which he was given upon his manumission. His wife is clad in a chiton, over which she is wearing a cloak. The intertwining of the two right hands, the *dextrarum iunctio,* is the visible symbol for the union as a married couple: it is not a loving look into the eyes of the other, but an unemotional declaration of the act that is shown to outsiders. The same is true of the reference to the fairly modest wealth they acquired: on the fingers of her almost rigidly outstretched left hand Aiedia is showing onlookers two rings as her own property. Publius Aiedius's face already shows clear signs of age, such as an emaciated neck, sunken cheeks under leathery skin, thin hair, as well as warts on the forehead and the mouth. Although it is doubtless the case that Publius Aiedius was only freed by his master at an advanced age and was for that reason not depicted as a man in the prime of life, this iconography of an old man was also meant to associate his image with the ancestor masks made of wax and clay which influential families had made of their deceased relatives and which they stored in the atria of the villas and carried along during funerary processions to demonstrate the accomplishments of their deceased family members. Publius Aiedius mainly wanted these facial features to show the world that he was a successful man who cared for his own. They were meant to show qualities such as *virtus,* excellence, and *dignitas,* dignity, which had helped him successfully rise from being a slave to being a Roman citizen.

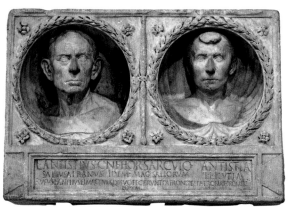

Part of the funerary monument to Lucius Antistius Sarculo, c. 10 – 30 BCE

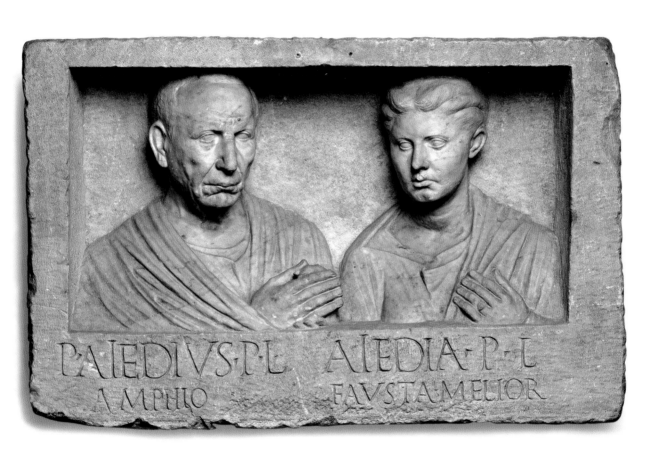

preparation of a theatre performance or a rehearsal for a satire

Mosaic made of differently coloured stones, height 52 cm, width 53 cm
Naples, Museo Archeologico Nazionale

The proclamation *panem at circenses,* "bread and circuses", is usually associated with the great spectacles to which the people of Rome and other cities in the empire went to be entertained. From daring chariot races with spectacular accidents of the participating teams, as were staged in the film "Ben Hur" for example; from deadly gladiator fights and gruesome animal chases, to proper naval battles. Besides all of these it should not be forgotten that the Romans also enjoyed theatre performances, tragedies as well as comedies and ribald satires.

Surely the latest "hits" that had been written for the stage were sung in the streets of Rome and elsewhere and the subtle references to the celebrity gossip at the imperial court were discussed behind closed doors. The poets found their models in their great predecessors in Greece, such as Aeschylus, Sophocles, Euripides, or Aristophanes and Menander.

Among the few surviving pieces or even just the fragments we mainly know about the comedies by Plautus and Terence as well as Seneca's tragedies. The comedies illuminate the daily life with its errors and confusions, deal with mistaken identities, a miserly pater familias, a boastful soldier, and a lot more. The tragedies, such as those by Seneca, were usually based on famous models from Greek mythology, such as "Oedipus the King", "Hercules Furens", or "The Trojan Women". Thus it is no wonder many an educated Roman did not just decorate his house with battle scenes from the arena, but also ornamented it with images taken from the theatre.

The *tablinum* in the "house of the tragic poet" was decorated with the mosaic shown here, which reproduces a scene from the world of theatre. As if on a stage that is outlined by two pillars and two columns – gilded containers stand on the attic above it – a bearded choir conductor is sitting, wearing a cloak, sandals, and holding a gnarled stick, in a circle of musicians and actors. In his right hand he is holding the female mask of tragedy; the mask of a silenus is lying beside it. Two actors with fur skirts are standing in front of the old man. The actor at the front seems to be rehearsing his movements, which the musician playing a double flute is accompanying with a melody; a further actor is standing behind the musician. At the right of the picture a wardrobe helper with a pointy headdress is trying to assist a silenus actor to get into a shaggy costume. A further bearded mask is lying on the podium to the front. The scene evidently depicts a rehearsal for a satire or the last preparations for the performance itself, even though the tragic theatre masks do not quite seem to fit. Maybe they were part of the actors' props. Presumably the depiction goes back to a painting by a Hellenistic artist, maybe it was a votive gift as thanks for a victory in a theatre competition. The obvious perspective distortions in the architecture – of the coffered ceiling for example – are doubtless due to the insufficient care of the copyist.

Mask of Tragedy from the Casa del Fauno, end of the 2nd century BCE

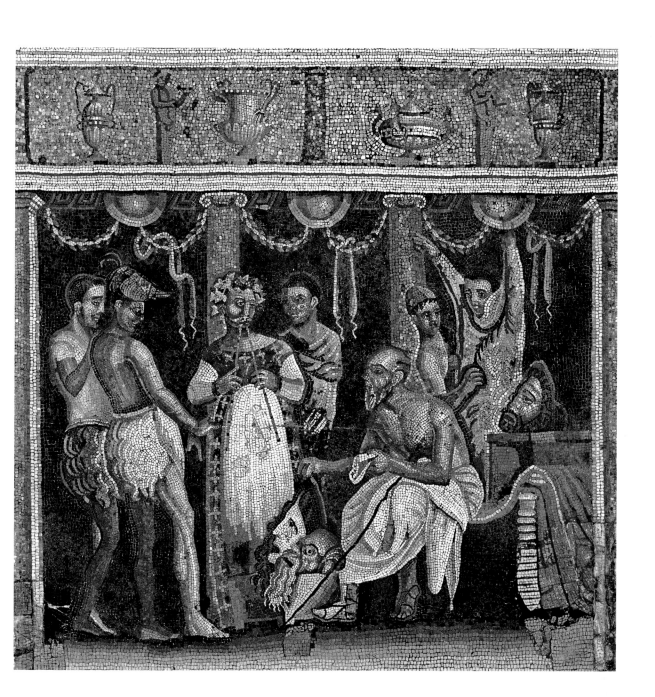

ᴛhe argument between spectators from ᴘompeii and ɴuceria in the amphitheatre of ᴘompeii

Wall painting
Naples, Museo Archeologico Nazionale

It appeared to be a nice day in the year 59 CE, when Livineius Regulus staged a gladiator fight in Pompeii's amphitheatre. Pompeii's inhabitants and those of the nearby town of Nuceria flocked to see it. What happened next can no longer be reconstructed properly. According to the Annals of the Roman historian Tacitus (14, 17) a minor argument – maybe about the performance of one of the gladiators – escalated into something of a bloodbath. Mutual taunting turned into insults, then they turned to throwing stones and finally they raised their swords. In the end the Pompeian *plebs* gained the upper hand, and numerous people were wounded or paid with their lives. The incident in the town at the foot of Mount Vesuvius was naturally reported to Rome, where Emperor Nero let the senate make the decision in this matter. The senate ordered the consuls to investigate. The punishment for the fans at the gladiator fight was draconian: no Pompeian was allowed to attend such games for ten years. The organizer Livineius and the others who were responsible for the fracas were banished.

Through a stroke of luck we also have a picture of this event, even though it is not of particularly good quality. An unknown Pompeian villa owner had a snapshot image of this event painted on the wall of his peristyle between images of gladiatorial contests. A distorted bird's-eye view looks down on the scene in the amphitheatre's interior and the events taking place outside of it. The description of the topography does correspond to reality: parts of the nearby city wall as well as the high outside stairwells, the external arches, and the detached upper tier. In the right of the picture we can recognize the palaestra with its large swimming pool. In the centre of the arena we can see people fighting. It is not clear however, if they are gladiators or members of the audience. Isolated arguments can also be seen on the partially emptied tiers, which could hold up to 20,000 people. While the traders in the foreground are still calmly advertising their goods under their wooden stands, we can see several gesticulating pedestrians behind them, and even further back on both sides of the amphitheatre the street riot is already in full swing – visitors are beating each other up and injured and dead people are lying on the ground.

Anyone who knows how popular gladiator fights, animal hunts and other cruelties were amongst Romans in the capital and other places can easily imagine how hard the Pompeians were hit by the decision from Rome. The enthusiasm for such privately sponsored or publicly hosted games was particularly great in Pompeii; the town had boasted its own stone amphitheatre since 70 BCE; it is the oldest still extant: Rome's *plebs* still had to wait another 100 years for theirs.

Gladiator fight with bull, stag and ostrich, 1ˢᵗ half of the 4ᵗʰ century CE, mosaic

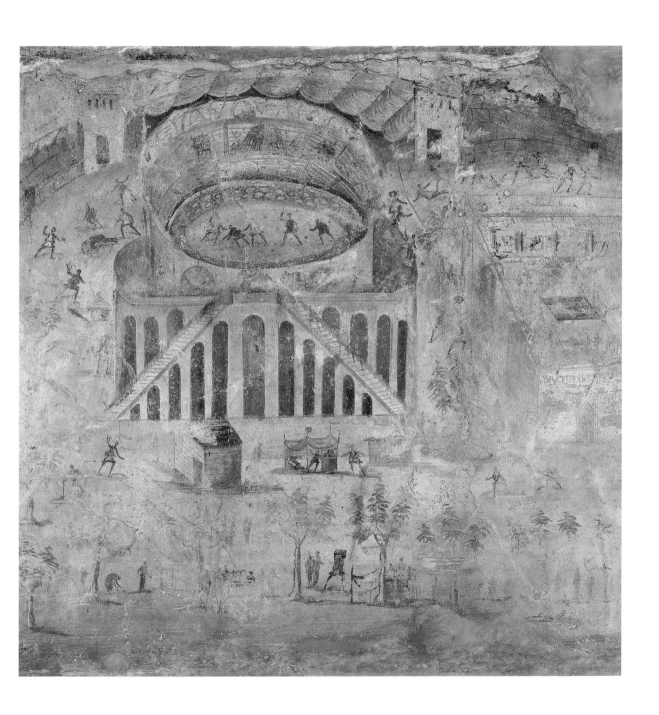

Depiction of a grave stone

Marble, height 131 cm, width 104 cm
Rome, Musei Vaticani

This relief provides an insight into the elaborate design of Roman mausoleums, which was part of the grave of the Haterii next to the Via Labicana near Rome. This family had risen to eminence and become wealthy.

On the left we can see a crane with five pulleys. The crane was moved by a large wheel with a double row of spokes, whose axis was connected to the lever. While two slaves are pulling at ropes under the wheel, five other slaves in the spokes are using their weight to turn the wheel, to bring the lever into the desired position. At the top two workers are attaching a basket with palm leaves and laurel – maybe a sign of a topping-out ceremony?

If the crane can probably be understood as a symbol for a successful and wealthy builder from the Haterii family, the building could be the grave for his deceased wife and their three children; the depiction of the crane in no way refers to the construction of the tomb, because that is already complete. The scene above the mausoleum's pediment is of course not there in reality. It visualizes something we are supposed to picture in the interior or rather something removed from our sight. The deceased is lying on a couch in front of a draped cloth, while her three deceased children are playing on the floor in front of it. An old woman, presumably a nurse, is making a sacrifice at a small altar. On the left we can see a large, lit candelabrum with griffin feet. On the right is a shrine, a naked Venus standing between its columns; maybe she was the goddess the deceased woman worshipped particularly, or maybe she represents the deceased woman in the guise of the seductive goddess of love. The three masks we can see above are most likely to be interpreted as ancestor portraits. The mausoleum itself could be accessed by the steps on the left. The building's interior, which served the death cult, could be entered via the swing door decorated with coffers and bosses located behind the columns entwined in vine tendrils. The capitals display eagles, the symbol of apotheosis, which carry the pediment, the symbol of heaven. In the pediment triangle the bust of the deceased woman with a veil over her head can – logically enough – be recognized, while her

children's busts can be seen at the sides decorated with small Eros figures and garlands; the depictions of the women below are probably the personifications of the virtues. The actual burial chamber lies at the foot of the podium, one of whose doors is standing open. In the opening to the underworld, so to speak, we can see the veiled deceased. The hero sitting on a basket holding a shovel next to the door is probably Hercules, as indicated by the attributes of club and bow. He is resting after the cleansing of the Augean stables. Just as Hercules, as the myth goes, once rescued Alcestis from Hades, the deceased seems to be waiting to be brought back to light by the hero – if not back into this life, then at least into a better afterlife.

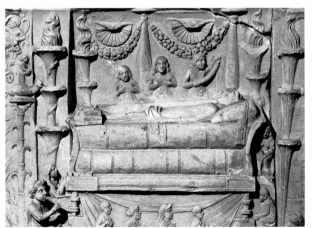

Relief from the Haterii grave monument, end of the 1st century CE

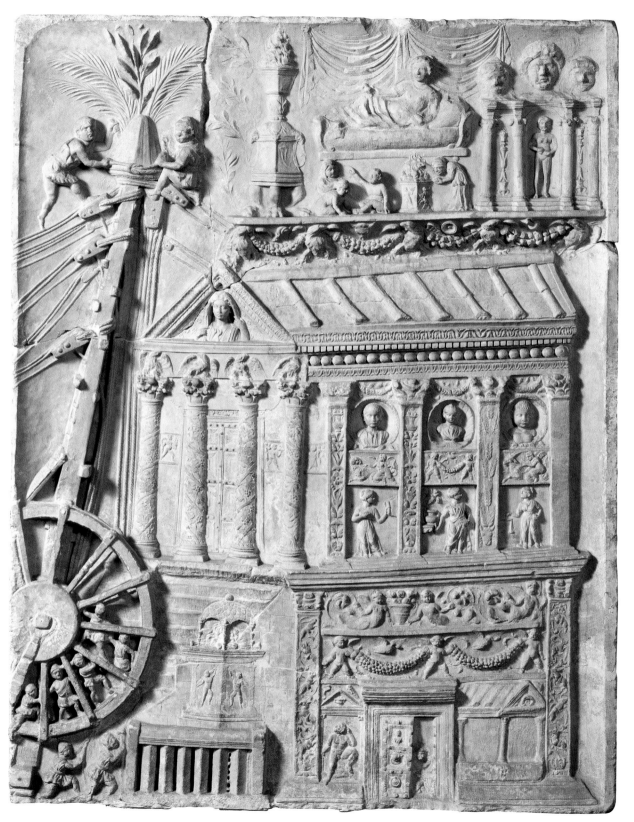

centaurs fighting wild animals

Mosaic from Hadrian's Villa, height 58.5 cm, width 92 cm
Berlin, Staatliche Museen zu Berlin – Stiftung Preussischer Kulturbesitz, Antikensammlung

The Roman villa was always the residential and utility building of a rural estate, which was always located outside of the city walls, but the appearance of such complexes changed considerably over time. When we now speak of a Roman *villa urbana* or a *villa marittima,* we usually mean the elaborate and generally grand short-term residences of rich landowners that were built in beautiful landscapes with wonderful panoramic views or on the coast. They were places of leisure and meeting places for educated discussions on art, theatre, and literature – probably best compared to the salons of the 19th century. Owners of such properties were local politicians, poets and businessmen who had gained wealth and respect, but particularly also the grandees of the empire, members of the old aristocratic families who determined the fate of the ever-growing empire in the senate of Rome. Cicero and Horace owned villas just as Caesar and the military commander Lucullus did.

The villas that were shaped by really unprecedented luxury however were those the emperors and their closest relatives built for themselves. The appearance of such estates was shaped by carefully landscaped gardens with ingenious fountains and many artworks, generous colonnades providing some respite from summer heat and inviting visitors to take a stroll, with dining and relaxation rooms with precious floor mosaics and elaborate wall paintings. While Livia, Augustus' wife, lived in a more modest villa in Prima Porta, her son and Augustus' suc-

Hadrian's Villa in Tivoli, c. 124 CE

cessor, Tiberius, could call a grand estate on Capri his own. The largest of all Roman villas was commissioned by Emperor Hadrian in Tivoli outside the gates of Rome; it would be more appropriate to speak of a palace city integrated into the landscape. It lacked nothing to make life pleasant. It speaks for itself that the decor was worthy of Hadrian. This included the floor mosaic shown here, one of the masterpieces of this genre, which decorated the floor of a *triclinium,* a dining room, just like the famous Alexander Mosaic in the Casa del Fauno. The subject of the picture is the battle of centaurs with wild animals. The lion is already lying on the ground with a smashed head, bleeding terribly. The tiger however has beaten a female centaur and is holding the seriously injured or even already dead centaur down with both paws. The tiger is doubtlessly the target of the big rock the centaur is planning to throw in the next instant, while his eyes seem to be fixed on the panther standing on a cliff ready to attack.

The scene is taking place in a rocky, rugged landscape with a few bushes. The tense atmosphere created by the different colouring of the stones, brushwood, and background together with a skilful use of perspective and the balanced picture composition prove the mosaic artist's mastery. Just as with the Alexander Mosaic this image probably also had a famous picture as a model, which was then more or less exactly copied as a mosaic. However, it will have to remain unanswered whether the model was a lost picture by the 5th-century Greek painter Zeuxis, who is said to have been the first painter to have painted a female centaur.

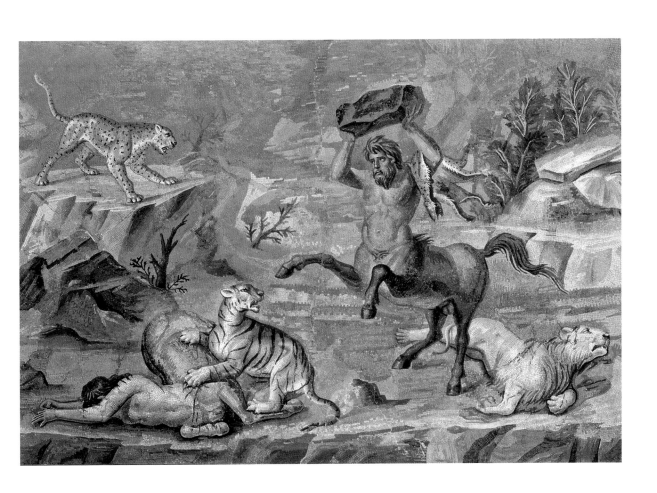

Equestrian statue of Marcus Aurelius

Bronze, gilded, height 4.24 m, length 3.87 m
Rome, Musei Capitolini (replica on the Piazza del Campidoglio)

One of the highest honours a Roman military commander could hope to obtain was the senate's decision to erect an equestrian statue to him in the forum. During the domestic conflicts that had started at the end of the third century BCE, the powerful members of the old aristocratic families bypassed the senate's ban on self-representation by declaring their equestrian statues sacred, presenting them as gifts to the deity: their own claim to power could also be proclaimed in such a setting. The iconographic formula probably did not experience any great variations, as we can see from the insert traces in the surviving pedestals. Generally speaking the rider was sitting on a horse that was calmly striding along. Over the centuries many such equestrian statues must have decorated the fora, marketplaces, and theatres of the Roman Empire. Usually only the pedestals have survived, sometimes also several fragments, but much more rarely a rider or a horse. Whatever was not destroyed by a political enemy in ancient times was recycled by people in later ages who were more interested in the metal than the art. Probably the most famous equestrian statue in art history is that of Emperor Marcus Aurelius, which Pope Paul III Farnese moved from the Lateran, where we know it had stood at least since the 10th century, to the Capitoline Hill early in 1538; set up in the centre of the square on a pedestal designed by Michelangelo. The statue, which is twice life-size, only escaped destruction because it was believed to portray Constantine or Theodoric the Great, that is, a Christian emperor.

The emperor, who is sitting on a heavy and elaborately bridled horse, is wearing the *paludamentum,* the cloak of a military general, over his tunic. His right arm is stretched out, either to greet his troops after a victorious battle, or also to impose peace. At one point there probably was a fettered barbarian below the charger's raised right front hoof. This was a quite common motif symbolizing the subjugation of foreign peoples. The philosopher, and after Hadrian the second-greatest philhellene, on the emperor's throne – his beard is significantly longer than that of his predecessor Hadrian and was meant to recall the typical philosopher's beard – is peering down from his horse with noble equanimity. This can be linked with Marcus Aurelius' modesty and lifestyle, as shaped by the philosophical school of the Stoics; the format of this likeness points in the same direction, because while the equestrian statues of Domitian and Trajan were four, five, or even six times larger than life, Marcus Aurelius contented himself with a monument that was approximately twice the size of the original: this ruler did not need any more. According to him his main duty was to look after his subjects: "What is my relationship to the people, that we are there for each other, and also that I am appointed to be their leader, like a ram leads a flock of sheep, or a bull leads a heard of cows." (Marcus Aurelius, *Meditations*, XI, 18)

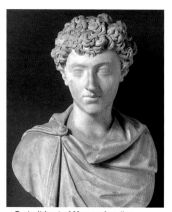

Portrait bust of Marcus Aurelius,
c. 170 CE

"ex humiliore loco in aream capitoliam" (from a lower place to the piazza on the capitoline)

From the inscription on the pedestal created by Michelangelo for the equestrian statue of Marcus Aurelius)

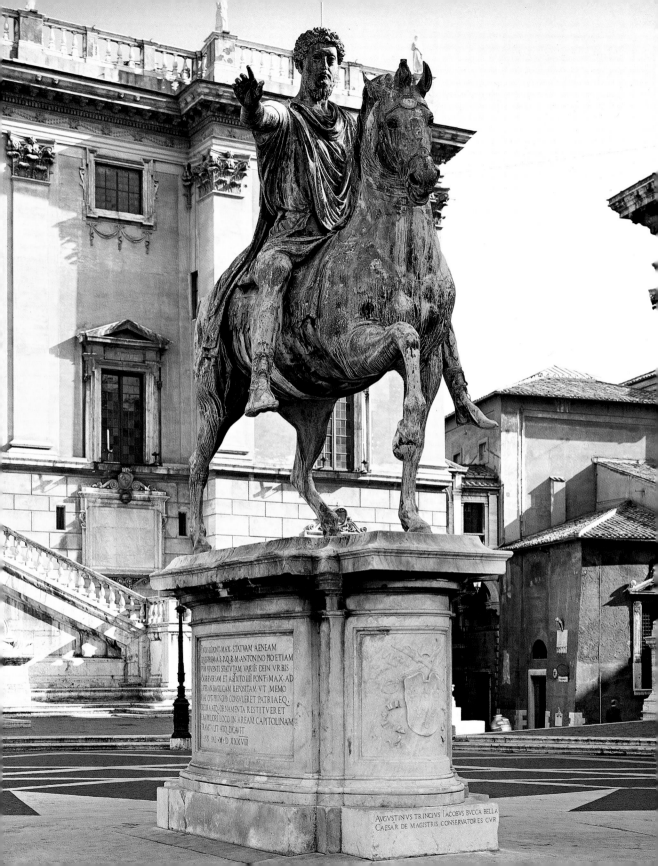

Portrait of a young woman (mummy portrait)

Encaustic painting on wood, height 44.3 cm, width 20.4 cm
London, The British Museum

A little-known genre of Roman portrait art gives us an insight into the beginnings of portrait painting, namely the fascinating portraits, often not duly noted by the museums of the world, that were mainly discovered in the Lower Egyptian oasis of Al Fayyum. Today we know of a few hundred of these likenesses painted on wooden panels – or more rarely on canvas – that were wrapped up together with the mummies. This wonderful gallery of the many anonymous people who died in Egypt between the 1st and early 4th centuries CE holds a particular fascination for the beholder, because the people gazing back at us from many of these likenesses look like people we could still meet in the streets of Mediterranean towns or in the bazaars of the Orient. They do not depict a colourless portrait carved into stone, but the face of a person made of flesh and blood, shown with carefully arranged hair or a wild beard, with a worried look, or a smile on the lips, in simple dress or with valuable jewellery. If we consider that the people who had themselves represented here were not members of the aristocracy of the Roman province of Egypt, who surely occupied the top rank of portrait painters, then the loss of these latter masterpieces must be lamented in the light of the often gripping and confident characterizations usually found in the Greeks, Romans, Africans, and others immortalized in the mummy portraits by the more second-rate portraitists. This suggestive quality is also possessed by the portrait of a young woman shown here. She is looking at the viewer with a slight turn to the left. The rosy face has an oval shape and a high forehead. The nose is classically straight and the full mouth seems to be

Gold necklace, Pompeii, 1st century CE

smiling. Below the thick brows, brown eyes with added highlights are peering at the viewer. The black hair with a centre parting is falling to both sides in wavy curls. The woman is dressed in a blue-violet chiton with gold-coloured stripes and a white-grey cloak over her shoulders. She is wearing a large amount of jewellery, which is probably a symbol of the wealth she possessed while she was alive. She is wearing a multi-layered, heavy gold necklace with alternating gold links and green stones set in gold. The middle link has an oval gold medallion with a red stone. Matching the necklace, the earrings also have green stones set in gold as well as a large pearl below on either side. The woman is wearing a thin-leaf wreath in her hair.

None of the gold jewellery elements has been painted; gold-leaf has been applied. Similar jewellery is also known from other locations of the Roman Empire and shows the high standard of craftsmanship attained by the goldsmiths of the time.

> "until mummification was prohibited in the late 4th century CE, a rich supply of likeness panels was created, which can be seen as regular death effigies. Their use for Egyptian mummies hardly influenced their appearance. Technically speaking these images reflect Greek conventions of idealization and Roman conventions of detail-rich depiction."
>
> Hans Belting, 1990

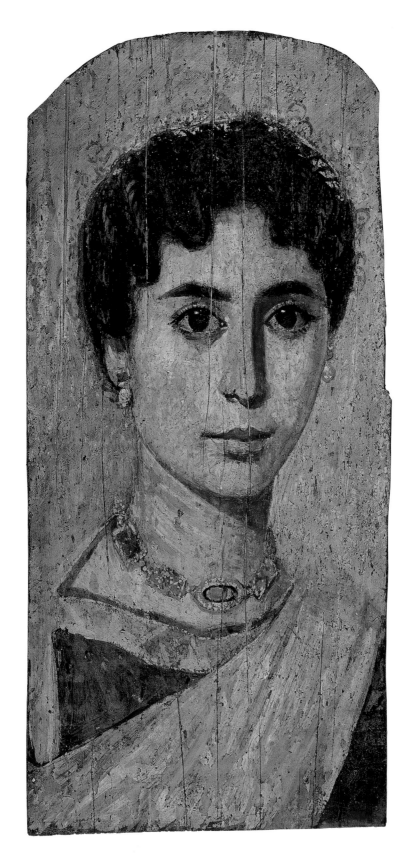

The family of septimius severus

Panel picture, tempera on wood, diameter 30.5cm
Berlin, Staaliche Museen zu Berlin – Stiftung Preussischer Kulturbesitz, Antikensammlung

The wooden tondo depicting the imperial family of Septimius Severus (reg. 193–211 CE) is a particular case of luck in the history of Roman art. It is currently the only painted portrait of the Roman emperor we have. We once again owe the survival of this rarity to Egypt's dry climate. This circular artwork gives an idea of the numerous likenesses that were made of the emperors and their family members besides all of the surviving portraits made of stone and other materials.

Painted emperor portraits must have also been less expensive than ones made of marble, whose paint, furthermore, has not survived. Septimius Severus, painted with quick and routine brush strokes on a white background, is shown in full regalia: he is wearing a precious gown and a jewel-studded, gold laurel wreath. He is holding a sceptre made of ivory. His two sons, twelve-year-old Caracalla and ten-year-old Geta (scratched out), are represented in the same manner in their regalia with a golden wreath and an ivory sceptre. Their mother, Julia

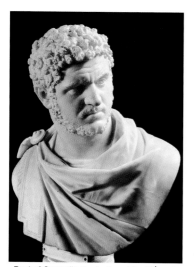

Bust of Caracalla, beginning of the 3rd century

Domna, is wearing a valuable necklace and precious earrings. This artwork was probably commissioned by one of the dignitaries in Egypt on the occasion of the imperial family's visit to the province in 199 CE. It could not hurt, particularly during those years, to announce one's loyalty to the imperial house by hanging and displaying such images of the emperor. Maybe there was also a concrete model for the depiction, because the composition shows a clear, official dynastic setup. The emperor's busts and those of his son Caracalla are placed in front of those of the empress and those of the younger son Geta, a clear iconographic definition of rank and thus succession to the throne: at that time Caracalla had already been elevated to the rank of Augustus, while Geta was only a Caesar. It had been intended that both of them would rule together after the death of their father. However, less than a year after Septimius Severus died in 211 CE Caracalla murdered his younger brother in the arms of their mother and also had a large number of his supporters killed in order to secure his sole rule. He demanded the senate to impose the feared *damnatio memoriae,* the extinguishing of the memory, on his brother through the destruction of all his portraits and inscriptions bearing his name. This is also the reason why Geta's portrait on the tondo was scratched out. His father had already had himself made emperor with the help of his troops in 197 CE after the assassination of his predecessor Commodus in 192 CE and the subsequent upheavals. The founder of the Severan dynasty was a Romanized African who married a Syrian woman. Outwardly, he tried to tie in with the time of Marcus Aurelius in order to legitimize the power he had acquired by violent means. Thus the official likenesses show him with the curly hair and the philosopher's beard of the wise and mild monarch. However, Septimius was no friend of Rome or Italy, let alone the senate. Instead he relied on the military, which then became the training school for retainers from Africa and Syria who had risen from the military ranks. Caracalla finally devalued the once so coveted status of Roman citizenship by giving it to all inhabitants of the empire in 212 CE. Thus the family picture with its propagandized harmony of parents and children, its proclamation of a firm succession to the throne, and the thus guaranteed security for the empire's inhabitants suddenly emerges as a fragile façade.

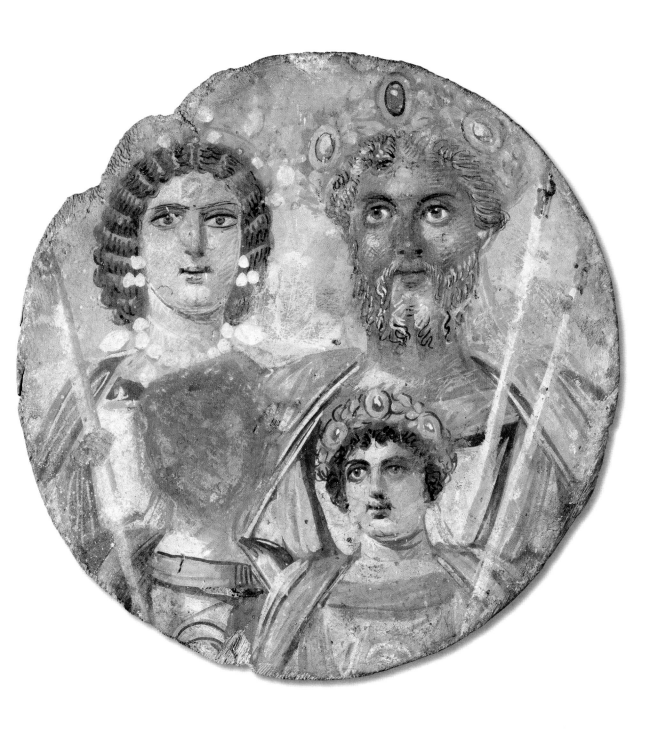

Hercules Farnese

Colossal statue, marble, height 3.17 m (without pedestal 2.92 m)
Naples, Museo Archeologico Nazionale

The term "colossal" is surely justified for this famous representation of the hero of all heroes in Greek mythology. Not just its size, but also its weight of 36 tons and its volume of over 13 cubic metres of marble confirm the special position of the *Hercules Farnese.* It is no wonder that the statue's sculptor had himself immortalized in the stone: Glykon Athenaios Epoeiei – Glycon of Athens made it. For art connoisseurs from the Renaissance to modern times the *Hercules* was a sensation, being considered the masterpiece of the otherwise unknown artist Glycon.

Without question Glycon superbly proved his abilities as a sculptor here; however: another colleague had the idea for this statue long before his time. The depiction of the muscly hero goes back to a work by Alexander the Great's court sculptor Lysippos, who created just such a statue in 330 BCE; we know of more than 90 reproductions of this Hercules in various formats. Even though the *Hercules Farnese* is thus "just" a copy of a lost original, it can still be called a masterly piece of work that confirms a high sculptural quality on the part of leading workshops and the copyists working there even in later years. The Roman Hercules, or rather the Greek Heracles, stands facing the viewer, only the lowered bearded head is slightly turned to the side. Without exact knowledge of human anatomy, without knowing the appearance of powerfully trained muscles and their changes through tension and relaxation, such a conclusive representation of a heavy athlete's body that Heracles was considered to have had would not have been possible. Since the centre of gravity was shifted to the left from the base, the hero is totally unable to stand on his own two

Hendrick Goltzius, Heracles
Farnese (rear view), c. 1592

feet, as it were. He seems to have completed some heroic deed and is supporting himself on his club which is standing on a rock covered by a lion-skin. His right hand is behind his back. In it Hercules is holding the apples of the Hesperides – the trophies of his last labour that promised him immortality. The club and the lion-skin – the prize of his first heroic labour – thus close the circle of the twelve Herculean "labours". In order to recognize this, viewers have to go around the statue, but then the front view immediately loses its dominance. The reconstructed installation of the Heracles/Hercules in the Roman Baths of Caracalla around 230 CE also support the supposition of there being two main views, which were also already staged by artists such as Hendrick Goltzius (around 1592). Thus the *Hercules Farnese* stood together with a counterpart whose motif was slightly altered, the so-called *Hercules Caserta* in the entrance to the frigidarium. Those coming to the frigidarium from the changing-rooms first saw the two statues from behind, i.e. the rear view. It was not until he was in the frigidarium, which was 1500 square metres in area and 34 metres high, that the visitor was able to see the colossal hero from the front. If we ignored this clearly planned and impressive staging of the Heracles/Hercules, we would not be doing the masterpiece by Glycon of Athens justice.

"Rome is facing a great loss of art.
The king of Naples is having the Hercules
Farnese brought to his residence.
The artists all mourn…"

Johann Wolfgang von Goethe, Italian Journey, 16th January 1787

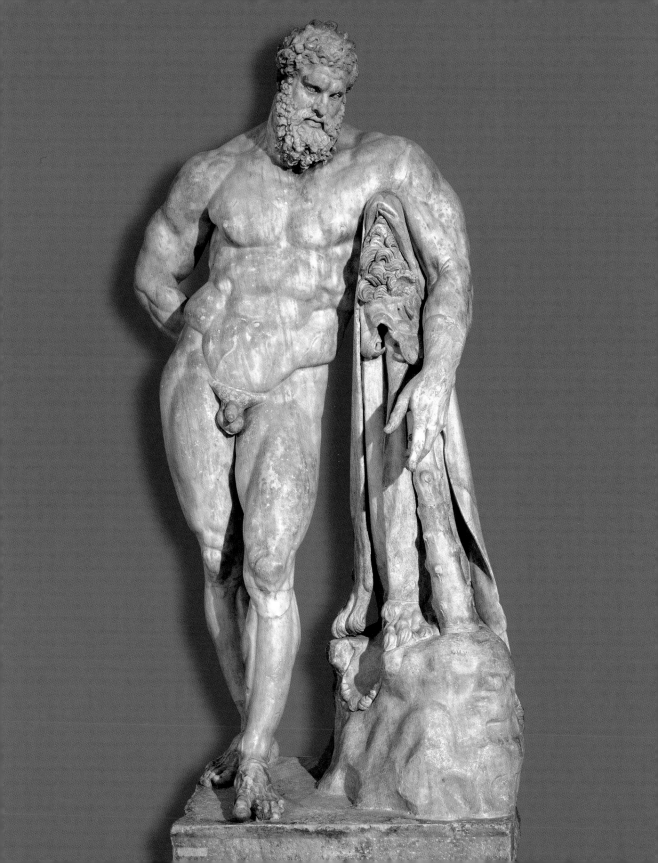

barbarian battle

Marble, length 2.73 m, width 1.37 m, height 1.53 m
Rome, Museo Nazionale Romano (Baths of Diocletian site)

A change in Roman burial customs can be recognized from the 2nd century CE. This change was marked by a gradual abandonment of the public show of the mausoleums with their elaborately designed facades. Instead families seem to have mourned their deceased relatives more and more privately and without pompous outward display during the funerals or commemorations. The most obvious expression of this altered religious conception is to be found in the sarcophagi decorated with reliefs that replaced the urns customary until that time. During the next two decades they developed into one of the most important genres of Roman visual art. The scenes could portray mythical events in which the deceased was represented as the hero Achilles or Meleager. However, sarcophagi with other subject matter also served the encomium of the deceased and his virtues such as excellence, piety, clemency, and more. A distinction is made between hunting sarcophagi, muse sarcophagi, and battle sarcophagi.

Acilia sarcophagus, 3rd century CE

One of the absolute highlights of the production of these sarcophagi, whose centres could be found in Rome, Athens, and in Dokimeion in Asia Minor, was the so-called *Grande Ludovisi Sarcophagus*. Not just its measurements are still impressive today – the almost 80-centimetre-high cover is lost – the artistic composition and craftsmanship are also particularly imposing. The subject is a battle between Ro-mans and barbarians. The first impression is one of a chaotic brawl. However, when we take a closer look we can recognize that every fighter, every group has an adversary or counterpart. The Roman soldiers with the portable trophies at the top on the sides correspond to each other just as the trumpet player on the left has a counterpart in the horn blower on the other side. There are almost exclusively barbarians depicted in the lower part of the frieze. They are either dead or wounded, and are shown to be either resisting or surrendering. The coarse, lank hair and beards emphasize the savageness of the opponents revolting against the clearly superior Romans: their lack of success is evident. The still young military commander on his charger appears as if from another world in this fray, gazing into the distance, his right arm elevated to an authoritative-triumphant salute. The victorious warrior has the facial features of the deceased.

The sarcophagus's unquestionably high sculptural quality, the singularity of this type in the middle of the 3rd century CE – the heyday of the battle sarcophagi lay between 160/70 and 200 CE – and the individually designed face of the military commander of course opened up the question very early on as to who the unknown man could be. One candidate is Hostilian, son of Decius (reg. 249–251 CE), who died of the plague in Rome in 251 CE; another is Herennius Etruscus, who, like his brother, fell at the battle of Abrittus that same year. However, even if comparisons with portraits make the one or other guess seem possible, there is no reason this sarcophagus should be that of an emperor's son. A citizen could also proclaim his ideals and virtues, in this case particularly courage and manliness, with allegorical pictures taken from the repertoire of imperial court art, which would then also document his closeness to the ruling household.

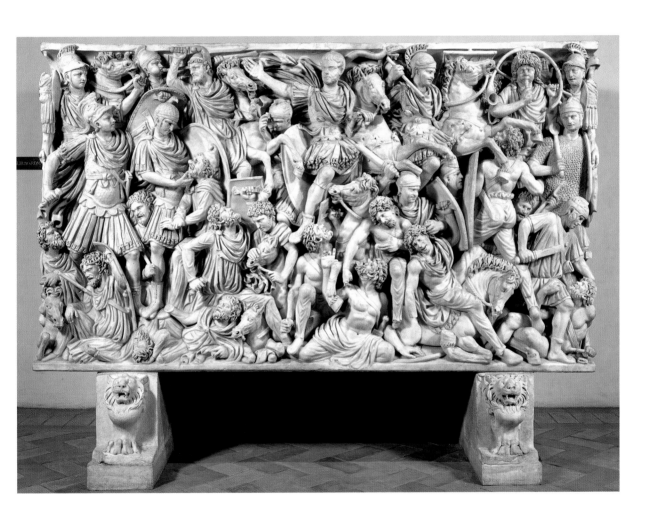

Portrait statues of the Four Tetrarchs

Porphyry, height 159 cm (with base plate)
Venice, Basilica di San Marco

The two groups of two of the rulers of the Roman Empire mark a historic break in the history of the ancient portrait. In comparison to the portraits of Augustus or Marcus Aurelius for example, the faces as well as the depiction of the bodies, which are connected by an embrace, appear more as awkward and woodcut-like than as a form decreed by the imperial court as appropriate for depicting the leaders of the empire.

However, it is the case. The political developments immediately after his victory over his opponent Carinus in 285 CE made it seem advisable to Emperor Diocletian (reg. 284–305 CE) to appoint a co-regent with whom he could share the empire's administration and defence. Diocletian took over the East, Maximian Herculius the West.

The foreign political situation also required further steps to ensure the security of the empire. Thus the two Augusti each appointed a Caesar as a younger co-regent for themselves in 293 CE, in order to cope with any threats to the empire with further "division of labour". The Caesares who were intended to succeed the Augusti and appoint their own Caesares in turn were Constantius Chlorus, the father of Constantine the Great, in the West and Galerius in the East. The joint responsibility naturally required *concordia,* harmony, from all of them, as the embrace by the two groups shows; but it also required *similitudo,* similarity, as well as new forms of monarchical representation. Thus the de-individualization of the portraits, as is also displayed by the Venetian groups, is the expression of tetrarchal sameness ideology. This and other determining aspects for the self-image of the powerful four can be recognized in the portrait representations.

The emperors are wearing the traditional dress of military commanders: a tunic with long, narrow sleeves, above which they are wearing a breastplate and a military cloak that is clasped on the shoulder; eagle heads crown the sword pommel and the half-open shoes with crossed straps conform to the newest trend. The beret-like caps were first seen on the tetrarchs. They were made of fur or felt and were part of the dress of the Illyrians, which at the time formed the most powerful unit of the Roman army: all the tetrarchs came from

Illyricum. Thus the caps were not just an acknowledgement of their native country, they also emphasized the *virtus,* the military valour of the rulers. For the first time the rulers are also shown in splendid regalia decorated with gemstones. As these were previously seen as characteristic of oriental monarchies they were frowned upon in Rome. However the gemstones on the belts, swords, shoes, and caps now started consciously documenting the monarchical status of the men depicted. The material used for the statue group also signified a charismatic exaggeration. The red porphyry from Egypt was now no longer used merely for the emperor's purple robes. By also using the porphyry for the portrait the ruler was meant to be completely infused by the imperial purple; evidently status was more important than nature. It is no wonder that porphyry became the favoured material of the imperial court for statues, architecture, and sarcophagi at this time.

Whether the two Venetian groups embodied the first tetrarchy or later ruler constellations is not yet clear. It is certain however that the two Augusti and the two Caesares are embracing each other as a symbol of mutual recognition and harmony. The hinted-at beards of two of the rulers were later additions; originally all four of them had smooth cheeks. Thus the faces marked by age and the slightly lowered corners of the mouth indicate the Augusti, while the two narrower heads belong to the Caesares.

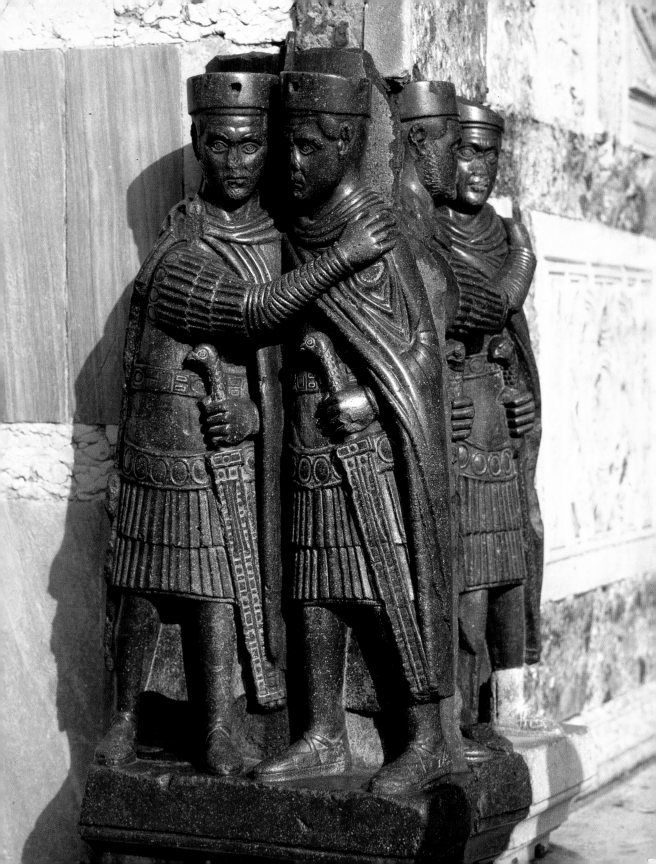

Triumphal arch for Emperor constantine the Great

Marble, height c. 25 m; central opening 11.45 m high and 6.50 m wide
Rome

Of the three surviving triumphal arches in Rome, in honour of Titus, Septimius Severus and Constantine the Great, the one erected closest to the Colosseum for Constantine is the most magnificent. The surviving inscription attests that the senate and the people of Rome dedicated this triumphal arch *(arcum triumphis)* to the Imperator Caesar Flavius Constantinus Maximus Pius Felix Augustus in gratitude for the successful revenge on the tyrant and his supporters. The tyrant was Maxentius, who had been killed in the battle at the Milvian Bridge outside the gates of Rome on 28 October 312 CE. The arch was only inaugurated on 25 July 315 CE, in the tenth year of Constantine's reign. After the death of his father Constantius Chlorus, a tetrarch, he had been hailed a Caesar by the troops in York, while Maxentius, the son of the tetrarch Maximian, had himself nominated in Rome. The system of tetrarchy founded by Diocletian, the rule of two Augusti and two Caesares over the Eastern and the Western parts of the empire, did not survive for very long. Maxentius died in 312 and in 324 Licinius, the last adversary, was also defeated, making Constantine the sole ruler.

The visual ornamentation and building decor of the *Arch of Constantine* consist of works dating from different eras. The south side shows victory goddesses with trophies and barbarians on the column pedestals. Victories can also be seen in the spandrels of the central opening, while the side openings depict river gods. These reliefs

Emperor Marcus Aurelius' ceremonial address to his soldiers, relief on the Arch of Constantine

were made for the arch as well as for the small surrounding friezes above, which tell the story of the military campaign against Maxentius. The circular images (more than two metres in diameter) or *tondi* came from an older monument. They show hunting and sacrificial scenes with Emperor Hadrian as the main character. Hadrian's facial features were altered into the portraits of Constantine and Licinius (who at the time was still a co-regent). The four reliefs next to the inscription, each more than three metres tall and flanked by shackled Dacian warriors from Trajan's Forum, were originally part of an arch for Emperor Marcus Aurelius. They show the Emperor's departure *(profectio)* to war and his return *(adventus)* after the victory. On the opposite side we can see the submission of a barbarian prince *(submissio)* and a handing out of money *(congiarium)* by the ruler.

On the other side of the *Arch of Constantine* the subjects used in traditional imagery to praise the emperor's cardinal virtues are repeated, i.e. his military valour, his clemency, his piety to the gods, his generosity to the people, and others. Apart from stylistic developments, the vocabulary introduced in the time of Augustus for the official worshipping of the emperor is also repeated here. For that reason the older reliefs could be seamlessly incorporated into Constantine's image programme. In the past, scholars tried to explain the reuse of older works on the *Arch of Constantine* with a lack of suitable sculptor workshops within Rome and a demise of the artisan culture, since the old capital was no longer the actual centre of the imperial court, which in turn meant there was a lack of wealthy customers to commission works. Today, scholars are more inclined to think this reuse represents an attempt by Constantine to identify himself with such emperors as Trajan, Hadrian, and Marcus Aurelius, whose reigns could be used as models for his own time.

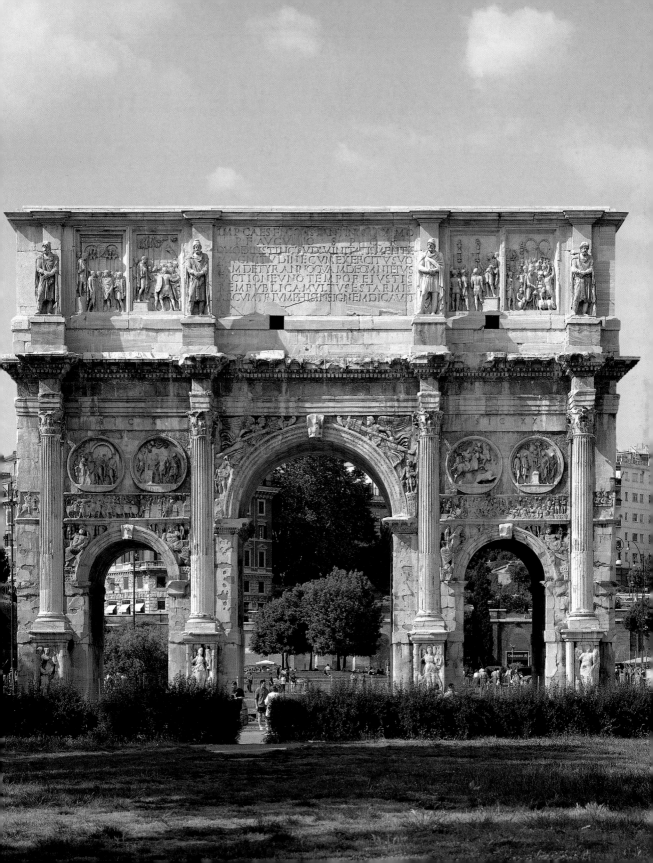

medal of emperor constantine the great

Silver, diameter 2.4 cm, weight 6.4 g
Munich, Staatliche Münzsammlung

This medal is a good example of the imagery of Roman ruler ideology valid since the early empire. At the same time it is a significant document of religious history. This issue was minted in 315 CE for the occasion of the decennial festival, i.e. the celebration of Constantine the Great's tenth anniversary as emperor of Rome, and for the festivities held at the same time in honour of his victory over Maxentius at the Milvian Bridge in 312 CE. That same year the *Arch of Constantine* was inaugurated in Rome. The medals were handed out to officers and soldiers as a gift from the emperor.

The medal's obverse side shows Constantine's portrait from a three-quarter angle. He is wearing his armour and a jewelled clasped helmet with an impressive plume. In his right hand he is holding the reigns of the horse that can be seen on the left in the background. In his left hand he is holding a shield and a sceptre. The round shield contains Rome's classical emblem: the she-wolf with the twins Romulus and Remus. The inscription names the ruler IMP CONSTANTINUS P F AUG.

The reverse shows Constantine in his armour, but without a helmet, on a podium, with his right hand elevated in the *adlocutio*-gesture, announcing a speech, while his left hand is holding a *tropaeum,* a victory symbol made up of pieces of enemy armour. The goddess Victoria is standing to the right behind him. She is holding a palm leaf and is placing a wreath on his head. This marks Constantine as a victor. He is surrounded by soldiers holding round shields and lances, as well as horses and

Medal of Emperor Constantine the Great, reverse

military standards. The inscription reads SA-LUS REI PUBLIC-AE, thus Constantine was successful in rescuing the state. The medal's picture programme, with its named motifs and the associated political contents and qualities of the emperor as a victorious military commander, fits seamlessly into the line of such proclamations on coins but also on state reliefs of the predecessors he held in high esteem. The special feature is on the coin's obverse: the plume's completion is formed by a round disc containing the *labarum* – the monogram formed of the Greek initial letters of Christ's name 'Chi' and 'Rho'. Thus the later account, according to which Constantine owed his victory over Maxentius to the Christian god, was already formulated in an image in 315 CE. According to Lactantius he was apparently urged to have Christ's monogram affixed to his soldiers' shields. Bishop Eusebius reported an apparition in which Constantine saw a cross in the sky as well as the words "in this sign you shall conquer!" So the notion of the victory at the Milvian Bridge under the Christian sign did not arise from pious or Christian historical misrepresentation years later, but was, rather, incorporated just three years after the battle into a symbol which made its way into the official imagery as a personal sign of salvation for the emperor and his troops. Of course this in no way implied a "conversion" of the Imperator to Christianity, because Constantine continued to make use of traditional Roman symbolism, worshipped the old gods, and only had himself baptized on his death bed. Christianity only became the state religion in 380 CE under Theodosius I (reg. 379–395 CE).

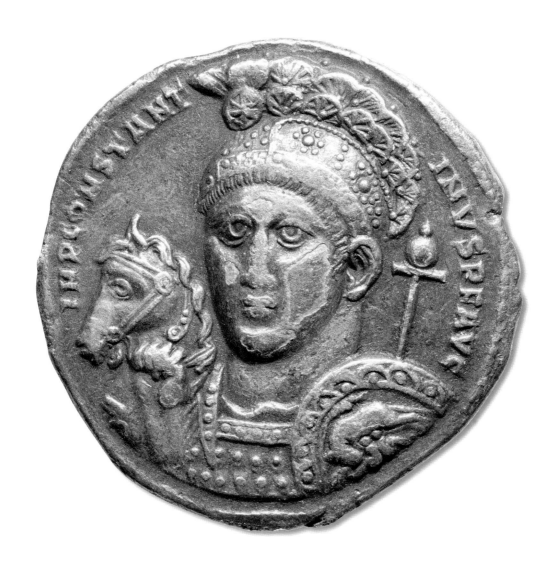

Head of a colossal statue of constantine

Marble, height 2.97 m
Rome, Musei Capitolini, Palazzo dei Conservatori

Constantine the Great and the senate in Rome knew how to celebrate the emperor's victory over Maxentius (reg. 306–312 CE) at the Milvian Bridge appropriately. *The Arch of Constantine,* completed in 315 CE and located close to the Colosseum, praised the emperor as their liberator from tyranny, which placed him and his actions in the tradition of great predecessors, such as Trajan, Hadrian and Marcus Aurelius. In the east of the city he had the Lateran basilica built for the god of the Christian community in gratitude for his victory. A few years later, no earlier than 318 CE, the basilica was consecrated to Christus Salvator, the saviour – a clear indication of the emperor's leaning towards Christianity. However another work which was also created after the victory in 312 CE is entirely in the Roman tradition of emperor iconography. It is a monumental statue of the emperor sitting on a throne – it must have been a good ten metres high – which celebrated Constantine as the new Jupiter and which he had erected in, of all places, the west apse of the forum basilica built by Maxentius – a different, but no less clear documentation of his personal victory right in the centre of Rome as well as a proclamation of his global entitlement to rule.

Apart from the surviving feet, the right hand, and other fragments it was particularly the emperor's colossal head that amazes anyone who sees it. The large, wide-open eyes with their heavy lids are quite striking. The wedge entering the pupil from above is probably an imitation of the typical re-

Hand from Constantine's colossal statue, between 312 and 315 CE

flection. His gaze is directly slightly to the side and upwards, into the distance, into the distant spheres of divine power so to speak. The portrait of Alexander the Great contained a similar statement. Whoever saw the statue in the basilica looked less at the individual countenance of the emperor, but rather experienced, as a subject, the divine majesty of a world ruler. The vertical wrinkles above the root of the nose are a tetrarchal traditional formula for effort and commitment. It is no coincidence that the sickle-shaped strands of hair carefully brushed on to the forehead recall the coiffure of Emperor Trajan. In comparison with the sometimes downright coarse iconographies of the barracks emperors, Constantine's portrait with his smooth cheeks and the overall more relaxed facial expression seems almost to emanate divine calm. In addition this radiantly youthful effigy is reminiscent of the equally classical-ageless portraits of Augustus.

Signs of adaptation in the area of his hair suggest the emperor originally wore a wreath or a diadem. An oak wreath is the most likely. The wreath was possibly replaced in later years by a bronze jewel diadem, which may even have been gilded. This item of the regalia of the Hellenistic monarchs only became typical of Constantine after 324 CE. But it is certainly conceivable that such a replacement of his headdress took place, namely on the occasion of his 20th anniversary as emperor of Rome in 325 CE.

The colossal effigy once showed the emperor partially wrapped in a full cloak sitting on a throne. He was probably holding a sceptre in his elevated right hand, while his left hand may have been holding a globe surmounted by the goddess Victoria. Such an iconographical harmonization to a formulaic image of the chief god of the city and empire, Iupiter Optimus Maximus, well-known throughout the entire Roman Empire, was clearly desired and followed a longer-running tradition. While the father god could hardly be seen in the narrow *cella* in his temple on the nearby Capitoline Hill, visitors to the basilica were able to experience the imperial world ruler as if under a magnificent firmament.

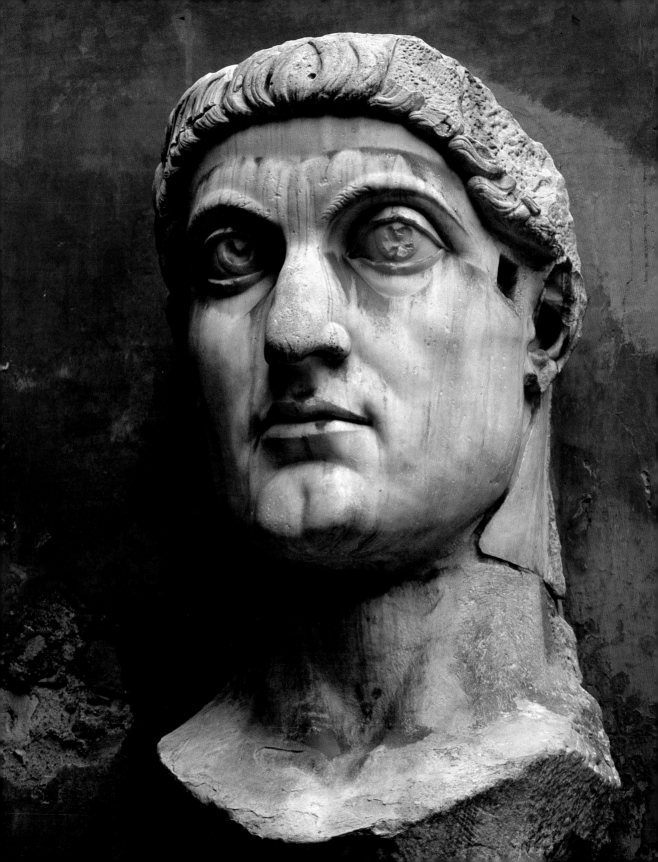

Lycurgus legend

Cage cup, opaque green, sanded glass, height 16.5 cm
London, The British Museum

The Roman glass industry produced many a masterpiece over the centuries and it is hardly surprising that the top pieces were traded at vast prices. Luxury cups like this impressively document the glass-blowers' technical ability. Finest facet cuts, carefully cut lines and finely engraved details awakened the desire of the wealthy as did the containers cast in two layers from blue and opaque-white glass with ornate scenes cut out so that in the end a relief picture on a blue background was created, comparable to the *Gemma Augustea.*

Manufacturing centres were located on the Syrian coast, in Alexandria, in Italy and also in Cologne; however, there were probably also appropriately trained glass-cutters in the imperial residence cities of Late Antiquity. The so-called cage cups are amongst the absolute highlights of glass art. During Late Antiquity they were considered the most precious and expensive glass category. Here, net-like ornament structures, inscriptions and figure-scenes were cut out of glass blocks three-dimensionally, so that they look as if their decoration were floating in front of the container body, or rather as if the decoration were just put on; and indeed it is often the case that the containers are only attached to their ornamentation by thin bridges.

This group's so far unmatched highlight is the cage cup made of an opaque-green block depicting the Lycurgus legend. The king of Thrace, Lycurgus, a wild character, once pursued a Dionysus procession and drove the god of wine into the ocean. Then he went after the Maenads, one of whom, Ambrosia, called to her mother Gaia for help. Mother Earth opened a chasm into which Ambrosia disappeared, but reappeared as a talking vine in honour of Dionysus. She taunted Lycurgus with her voice and with her vines she fettered him, whereupon the other Maenads surrounded and tortured him. The images on the cup capture three moments from this legend: Ambrosia calling to her mother for help, while Dionysus with Pan and a panther are already there ready for revenge. However, the main motif is not the naked, bearded Lycurgus himself, who is being shackled inescapably by the vines growing from a branched grapevine. The container, protected in the 19th century by a mounting of gilt bronze and a raised foot, must have belonged to a rich and probably also powerful owner. He will have shown many a guest how light caused the glass to transform from green to a fiery red. Like so often the depicted myth may have served to celebrate an actual historical event. Whether the occasion for the manufacture of the cup was the victory of Constantine the Great over his opponent Licinius in 324 CE, securing sole rule for the emperor, as has been speculated, remains questionable, despite the tempting nature of this idea.

Lycurgus cup, unlit

"You punish your defiers, honourable Pentheus, Lycurgus/ who carries the double axe; you chased the Tyrrhenians into the sea;/ a pair of lynxes obediently pull your carriage – with colourful/ reins they are decorated; – Bacchae follow and satyrs/ and the drunken old man: on the back of a bent donkey's back/ he hangs loosely, the swaying limbs supported by the pipe."

Ovid, Metamorphosis, 4, 22ff.

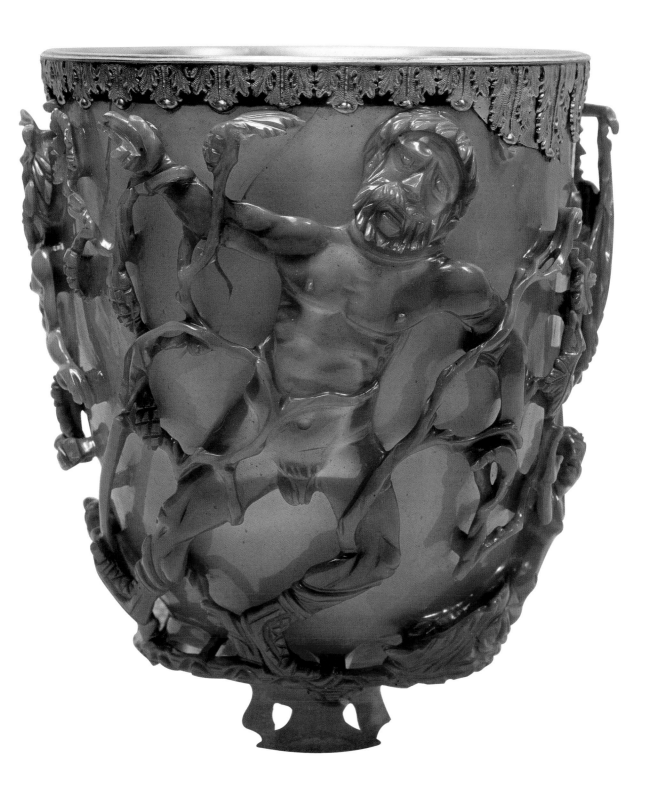

silver platter with scenes from the Achilles myth

Silver, height 3.9 cm, diameter 53 cm, weight 4643 g
Augst, Römermuseum/Roman town Augusta Raurica

For archaeologists it is a surprise of a very special kind to find "treasure" during their excavations. Usually these are valuable objects, often coins, but also precious metal ingots or jewellery, which their owners buried in the ground to hide them from thieves or enemies, or so as not to carry any dangerous ballast with them when they needed to escape. Once the danger was over or when the owner returned from their flight the property could be retrieved from its hiding place. However: very often the owners were killed or were unable to get back into their house. If none of the intruders found the treasure either by chance or because of some clues, it would remain hidden until its chance discovery by modern excavators.

The owners of the silver treasure of Kaiseraugst, 186 coins and 84 pieces of tableware, could not get to their possessions anymore, which they had buried in a wooden box in 351 or 352 CE within the walls of the late-Roman fort of *Castrum Rauracense.* The fort was taken and burned down by the Alemanni. Whether the owners met their deaths there or whether they fled during the ensuing up-heavals of war, is unknown. Weighing 57.5 kilograms the ensemble of coins, platters, trays, spoons, cups, bowls, and other items is one of the most significant discoveries of Roman silver worldwide.

One of the owners was a certain Marcellianus, as is confirmed by inscriptions on some of the items; the other portion belonged to someone unknown. Both must have been officers; Marcellianus was a tribune, i.e. a commander. Three silver ingots of the usurper Magnentius, who tried to overthrow the emperor of the West, Constans, in 350 CE, show that Marcellianus was evidently an adherent of the new ruler, who however was unable to hold on to power for long.

One of the most outstanding pieces of the silver treasure is the so-called Achilles platter, which names the metalworker in a Greek inscription. It was a man called Pausilypos in Thessaloniki. It can be assumed with good reason that the Achilles platter was a generous gift from the emperor to a high-standing personality; it remains uncertain however how it came into the possession of an officer in former Gaul. The edge of the octagonal platter is decorated with scenes taken from the life of the young hero Achilles before his participation in the Greek military campaign against Troy. In the centre we can see the exposure of the hero on Skyros by clever Odysseus. Achilles had dressed up in women's clothing in order not to be discovered. When however Odysseus blew the war trumpet the hero threw the clothes away and reached for the weapons – there was now no longer any excuse and the fate of the great warrior outside the gates of Troy is well-known. In the late-Roman period Achilles conformed to the current ideal of beauty, virtue, and of course courage, as did Alexander the Great. Picture stories taken from the biographies of such role models were thus particularly suitable for artworks and articles of daily use for military dignitaries.

The value of the silver treasure of Kaiseraugst was sizeable for the time. The coins, with a nominal value of 239.5 denarii, could buy 800 kilograms of corn, the silver tableware equalled the value of 63 tons of corn, and the entire silver treasure could have been used to pay the annual salary of 230 soldiers.

Central medallion of the Achilles platter

Recovery of Relics

Ivory relief, height 13.1 cm, length 26.1 cm
Trier, Schatz der Hohen Domkirche

==

One of the most precious materials used during Late Antiquity for official gifts and valuable presents in the private circle of the rich and powerful was ivory. The elephant tusks from India and Africa were mainly used by the highest officials for the manufacture of richly decorated two-part tablets or diptychs, with which they could announce their assumption of office to their friends or high-ranking personalities. Since the empire had been split into an Eastern and a Western half, the workshops for such treasures were located in Rome and Constantinople; the relocation of the power centres to other locations such as to the province of Gaul, where Constantine the Great initially resided in Trier, meant that such precious items were also manufactured there. Certainly this artistic and detailed relief was made in Constantinople; it did not however serve to announce an assumption of office, it rather addressed an event in the still young state religion of Christianity: the recovery of martyr relics. Against the backdrop of a large building we can see a procession leading to a just completed church at the right of the picture; on the roof of the nave we can see craftsmen still finishing it off. The front of the procession, made up of high officials, is headed by the emperor, crowned by a jewelled diadem and clad in a richly embroidered tunic held

Reliefs from the Arch of Galerius, 4th century CE

by a precious clasp. He is being awaited by the empress, who is shown in pearled regalia. She is carrying a large cross over her shoulder. In the left of the picture we can see two bishops seated in a four-wheeled carriage being pulled by mules. They are holding a relic in their hands, which is evidently meant for the new church. In the pediment above them we can see a bust of Christ with a halo and a cross. In the background are onlookers in the round arches, in the windows, and on the top floor. While some are marvelling, the observers in the middle row are swinging thuribles and singing. It is highly likely that the relief depicts the consecration of the St Mary Chalkoprateia in Constantinople under Theodosius II in 449 CE. Thus the building in the background is the Basilica of Constantinople, which was built on an artificial foundation. The relics that were kept in the St Mary Chalkoprateia were all somehow connected to the childhood of Jesus Christ. The entire scene matches the *adventus* representations since the early imperial period. This ceremonious arrival of the powerful and victorious ruler was possibly the most important ceremony of the Imperial era. The Arch of Galerius in Thessaloniki still shows the emperor's departure, *profectio,* from a town in a carriage in the right of the relief. The journey leads into another town on the right side of the picture frieze. There, his *adventus,* his arrival, is celebrated by the inhabitants with torches, branches, and gestures of welcome.

Through the transfer of this pagan-Roman event into a Christian relic recovery it becomes clear which aura and power the relics possessed. Thus we can grasp an important phenomenon from this richly narrated representation, which stood at the transition between Antiquity and the early Middle Ages: the power of the emperor was now based on his proximity to the new, one and only god.

To stay informed about upcoming TASCHEN titles, please request our magazine at www.taschen.com/magazine or write to TASCHEN America, 6671 Sunset Boulevard, Suite 1508, USA-Los Angeles, CA 90028, contact-us@taschen.com, Fax: +1-323-463.4442. We will be happy to send you a free copy of our magazine which is filled with information about all of our books.

© 2007 TASCHEN GmbH
Hohenzollernring 53, D–50672 Köln
www.taschen.com

Project management: Ute Kieseyer, Cologne
Editing: Werkstatt München · Buchproduktion, Munich
Translation: Michael Scuffil, Leverkusen
Layout: Sascha Rupp for Werkstatt München, Munich
Production: Ute Wachendorf, Cologne
Design: Sense/Net, Andy Disl and Birgit Reber, Cologne

Printed in Germany
ISBN: 978-3-8228-5454-9

Reference pictures:
p. 26: *Chimera of Arezzo,* Etruscan, early 4th century BCE. Bronze, height 80 cm. Florence, Museo Archeologico Nazionale
p. 30: *Statue of Augustus sacrificing,* from the Via Labicana, late 1st century BCE. Marble, height 217 cm. Rome, Museo Nazionale Romano (Baths of Diocletian site)
p. 34: *Statue of Venus, so-called Esquiline Venus,* c. 45 CE. Marble, height 155 cm. Rome, Musei Capitolini, Palazzo dei Conservatori
p. 36: *Roman denarius with a portrait of Gaius Julius Caesar,* by mint-master p. Sepullius Macer of Rome, 44 BCE. Silver. London, The British Museum
p. 38: *Portrait bust of Cicero,* c. 50–43 BCE. Marble, height of the head 36 cm. Rome, Musei Capitolini
p. 40: Illusionist wall decoration from Villa Boscoreale, Pompeii, 2nd half of the 1st century BCE. Painted wall stucco. New York, The Metropolitan Museum of Art
p. 42: *Portrait bust of Livia Drusilla (Livia Augusta),* c. 20 CE. Marble, height 42 cm. Bochum, Kunstsammlung der Ruhr-Universität
p. 44: *Portrait bust of Emperor Vespasian,* between 69 and 79 CE. Marble, height 40 cm, IN 2585. Copenhagen, Ny Carlsberg Glyptotek
p. 46: *Apollo and Hercules argue about the tripod,* end of the 1st century BCE. Terra cotta, painted, height 71.5 cm, width 62 cm. Rome, Antiquario Palatino
p. 50: Caryatid, about 20 BCE. Detail from the fresco décor in Cubiculum B in the Villa Farnesina in Rome. Rome, Museo Nazionale Romano (Baths of Diocletian site)
p. 52: Full view of the *Ara Pacis,* 9 BCE. Marble, dimensions of the hallowed ground 11.60 m x 10.60 m, base area of the altar 6 m x 7 m. Rome, Museo della Civiltà Romana
p. 56: *Forum Augustum with the Temple of Mars Ultor* in Rome, about 1890. Wood engraving after a drawing by Georg Rehlender
p. 58 *Cameo with the Three Graces,* 1st century CE. Naples, Museo Archeologico Nazionale
p. 60: *Tomb of Caecilia Metella* on the Via Appia Antica in Rome, about 1880. Lithograph with background plate by Carl Votteler from: *Album des Klassischen Altertums,* edited by H. Rheinhard, 3rd edition, 1891
p. 62: Part of the *Funerary monument to Lucius Antistius Sarculo,* a Roman priest, with his wife, c. 10–30 BCE. Marble, 63 cm x 98 cm. London, The British Museum
p. 64: *Mask of Tragedy from the Casa del Fauno,* end of the 2nd century BCE. Detail of a mosaic frieze, height 49.7 cm. Naples, Museo Archeologico Nazionale
p. 66: *Gladiator fight with bull, stag and ostrich,* 1st half of the 4th century CE. Rome, Museo Galleria di Villa Borghese
p. 68: *Relief from the Haterii grave monument,* end of the 1st century CE. Marble. Rome, Musei Vaticani, Museo Gregoriano Profano
p. 70: Hadrian's Villa in Tivoli, c. 124 CE
p. 72: *Portrait bust of Marcus Aurelius,* c. 170 CE. Marble. Rome, Musei Capitolini
p. 74: Gold necklace from Pompeii, 1st century CE. Gold, pearls, and emeralds. Naples, Museo Archeologico Nazionale
p. 76: *Bust of Caracalla,* beginning of the 3rd century CE. Marble. Naples, Museo Archeologico Nazionale
p. 78: Hendrick Goltzius, *Heracles Farnese,* c. 1592. Copper engraving. London, The British Museum
p. 80: *Acilia sarcophagus,* 3rd century CE. Marble. Rome, Museo Nazionale Romano (Baths of Diocletian site)
p. 84: Marcus Aurelius, scene from the Marcomannic Wars, c. 174 CE. The emperor's ceremonial address to his soldiers (adlocutio). Relief from a Marcus Aurelius building. Re-utilised on the Arch of Constantine in Rome, on a southern-side attic
p. 86: Verso of the *Emperor Constantine I medallion,* 315 CE. Diameter 2.4 cm, weight 6.4 g. Munich, Staatliche Münzsammlung
p. 88: A column, a hand from Constantine's colossal statue and a relief with the personification of a Roman province, between 312 and 315 CE. Rome, Musei Capitolini, Palazzo dei Conservatori
p. 90: *Cage cup with representation of the Lycurgus legend, so-called Lycurgus cup,* 4th century CE. Unlit. Opaque green, sanded glass, height 16.5 cm. London, The British Museum
p. 92: Central medallion of the *Achilles plate* from the Silver Treasure of Kaiseraugst, 330–340 CE. Achilles allows himself to be recruited by Odysseus. Silver, height 3.9 cm, diameter 53 cm, weight 4643 g. Augst, Römermuseum/Roman town Augusta Raurica
p. 94: Reliefs from the *Arch of Galerius,* 4th century CE. Thessaloniki

Portrait bust of Seneca from the Villa dei Papiri in Herculaneum
1st century CE, bronze, height 33 cm
Naples, Museo Archeologico Nazionale

Mural painting of the head of a woman from Pompeii
1st century CE, fresco
Privately owned

Still-life with cat, bird and ducks
Roman mosaic from Pompeii, c. 50 CE
Naples, Museo Archeologico Nazionale